WELCOME! We hope you enjoy this Fave Art-12 album collection of favorite paintings (classic & modern). Most are copied from the internet, posters, prints and books. You may display this book as coffee table book in your living room, as conversation piece. You may give this as gift. You may cut out and frame each page. Each work is 8.5x11 inches and suitable for framing, and for wall decors.

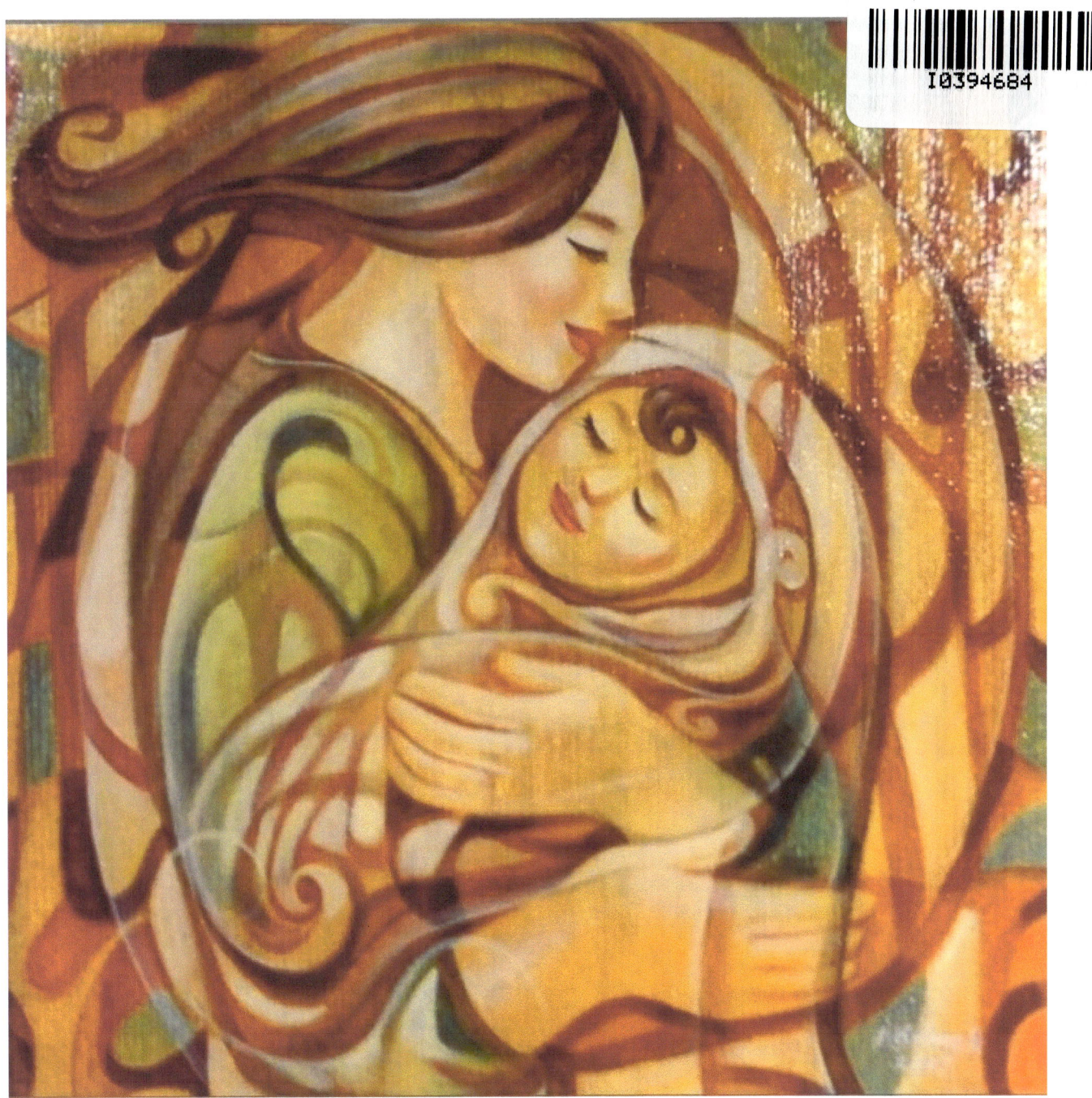

Mother & Child by Joeyboi Galang, 2016

The ISBN Code Numbers of this book are:
ISBN-13: 978- 1547228133 & ISBN-10: 154722813X
Printed in USA. Free to copy by anybody. Why copy? Just buy the book.
Book List at - http://tinyurl.com/mj76ccq & http://www.jobelizes6.wix.com/mysite.
My contact email is job_elizes@yahoo.com. (Tatay Jobo Elizes, Pub.)

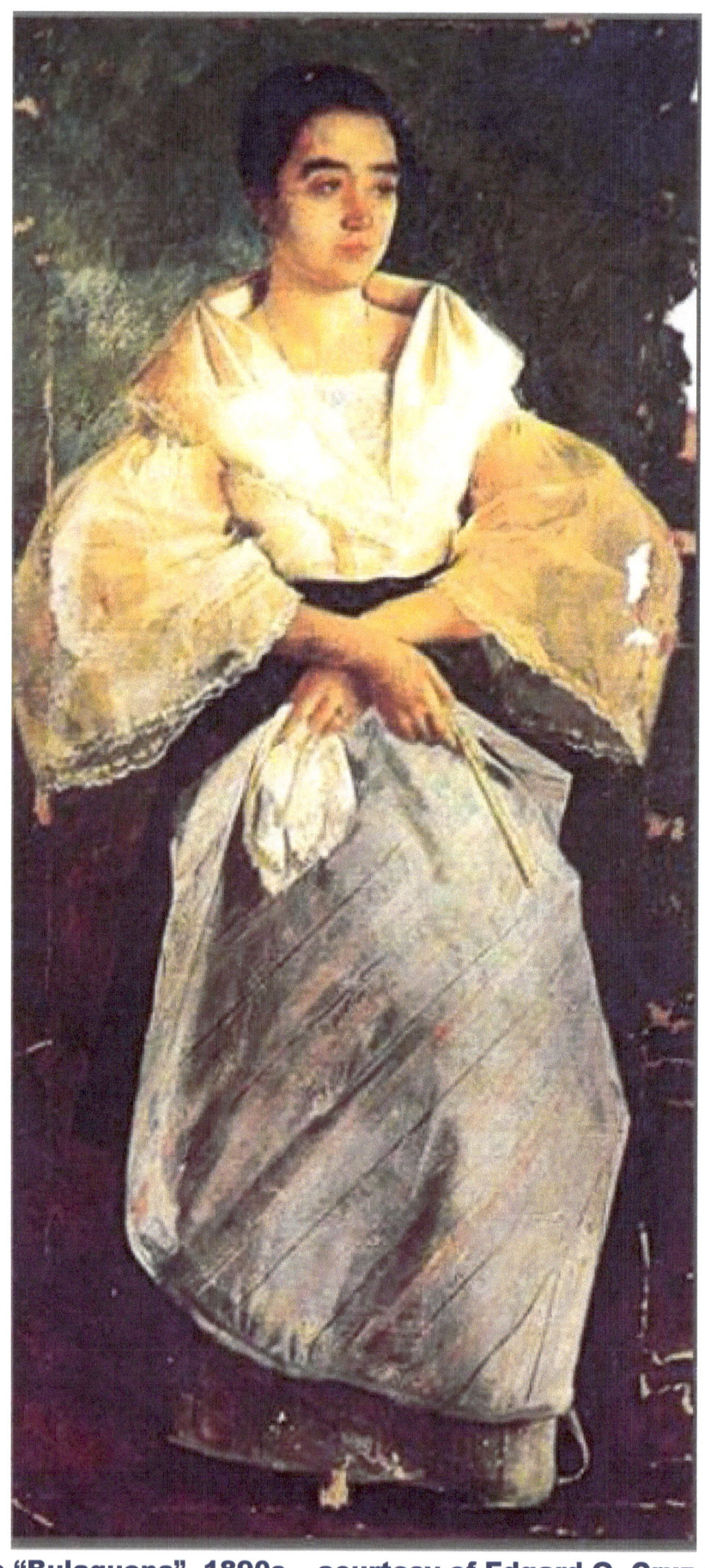

Juan Luna's "Bulaquena", 1890s – courtesy of Edgard O. Cruz at facebook

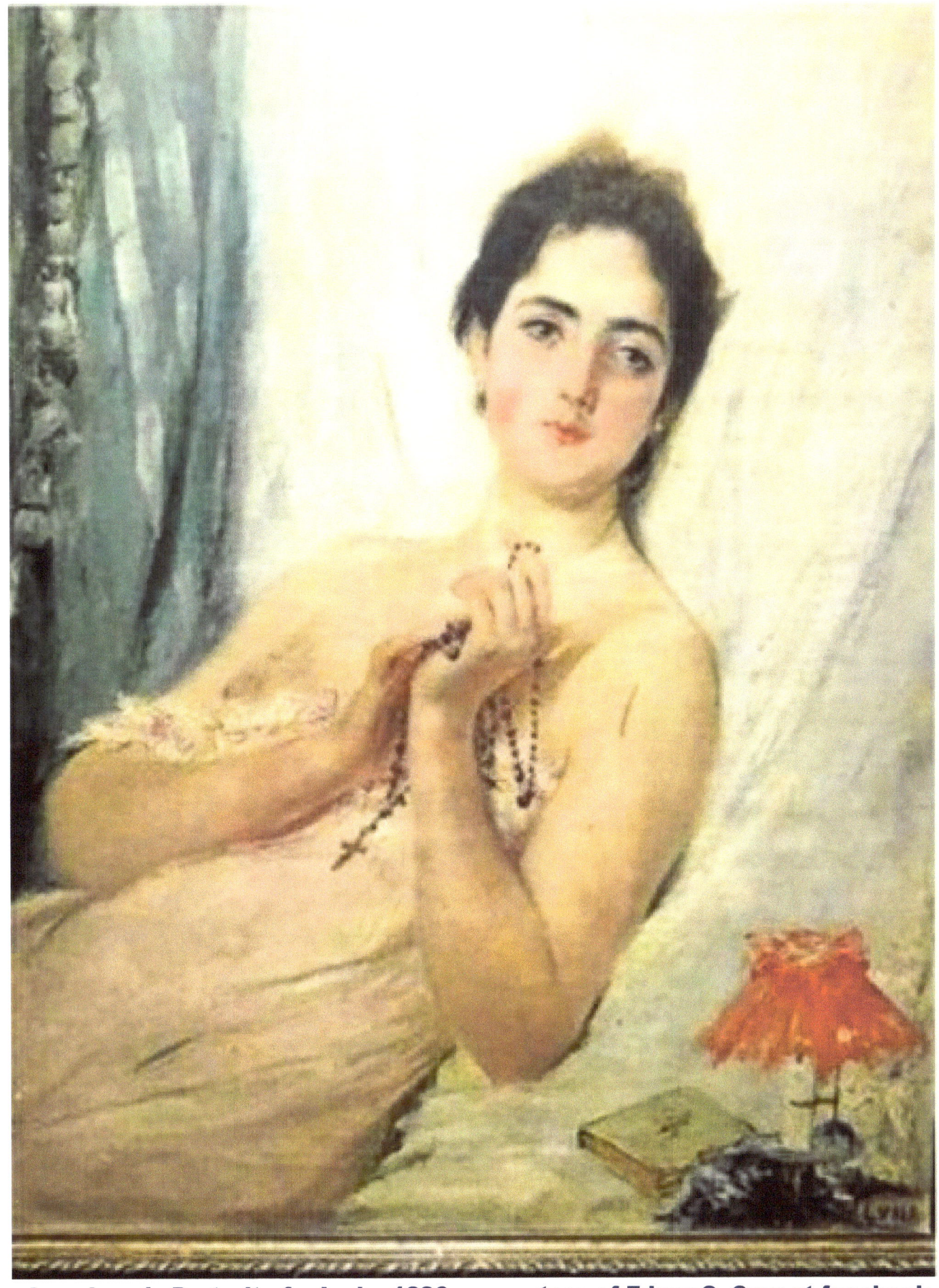
Juan Luna's Portrait of a Lady, 1890s – courtesy of Edgar O. Cruz at facebook

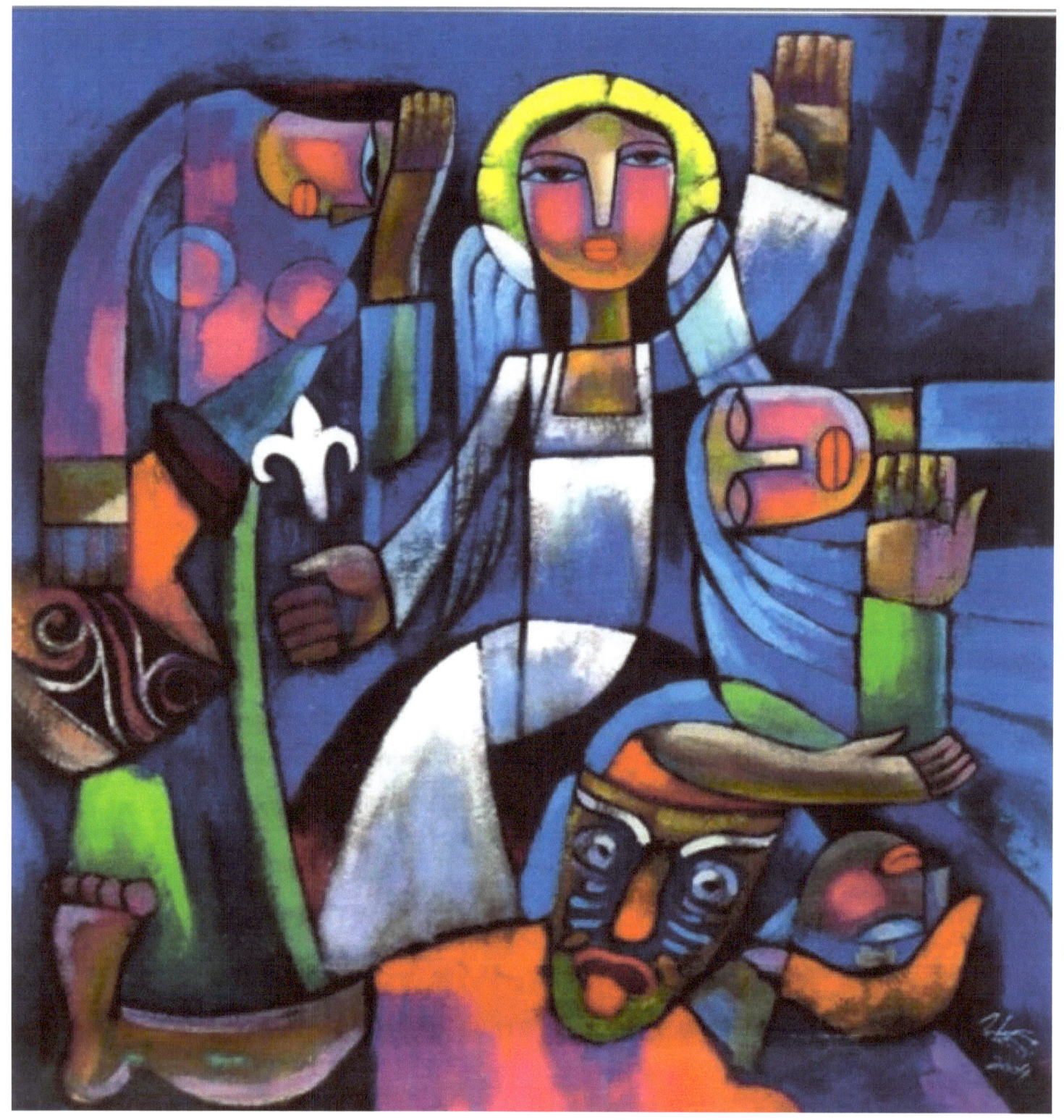

Unknown Pinoy beautiful abstract painting discovered online

WELCOME! We hope you enjoy this Fave Art-12 album collection of favorite paintings (classic & modern). Most are copied from the internet, posters, prints and books. You may display this book as coffee table book in your living room, as conversation piece. You may give this as gift. You may cut out and frame each page. Each work is 8.5x11 inches and suitable for framing, and for wall decors.

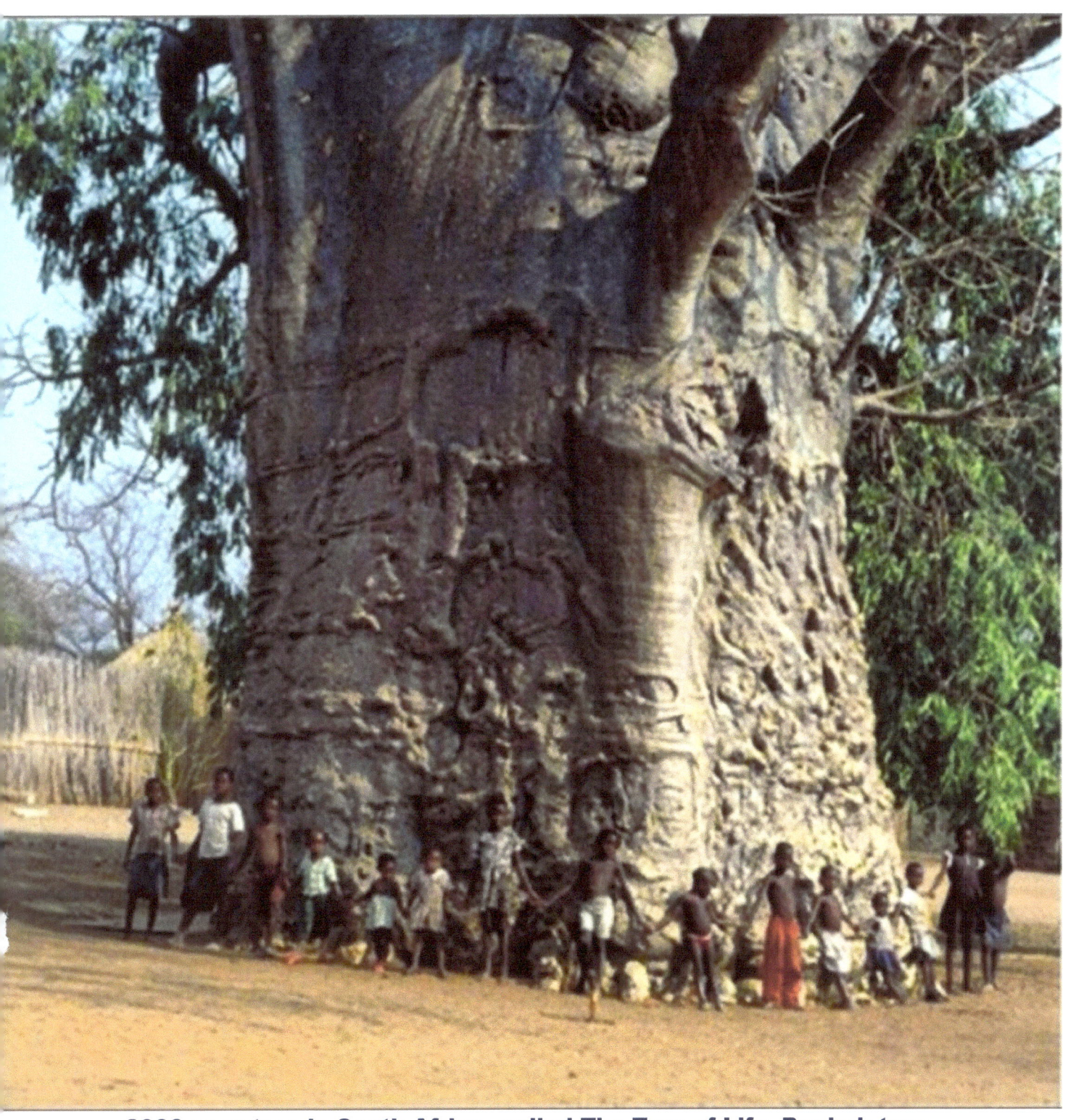

2000-year tree in South Africa, called The Tree of Life, Boabab tree.
Hollowed out trunks provide shelters to 40 people, provide 4500 liters
of water, bark fibers used as rope, fresh leaves are medicinal.
(this is a picture, not a painting, worth displaying)

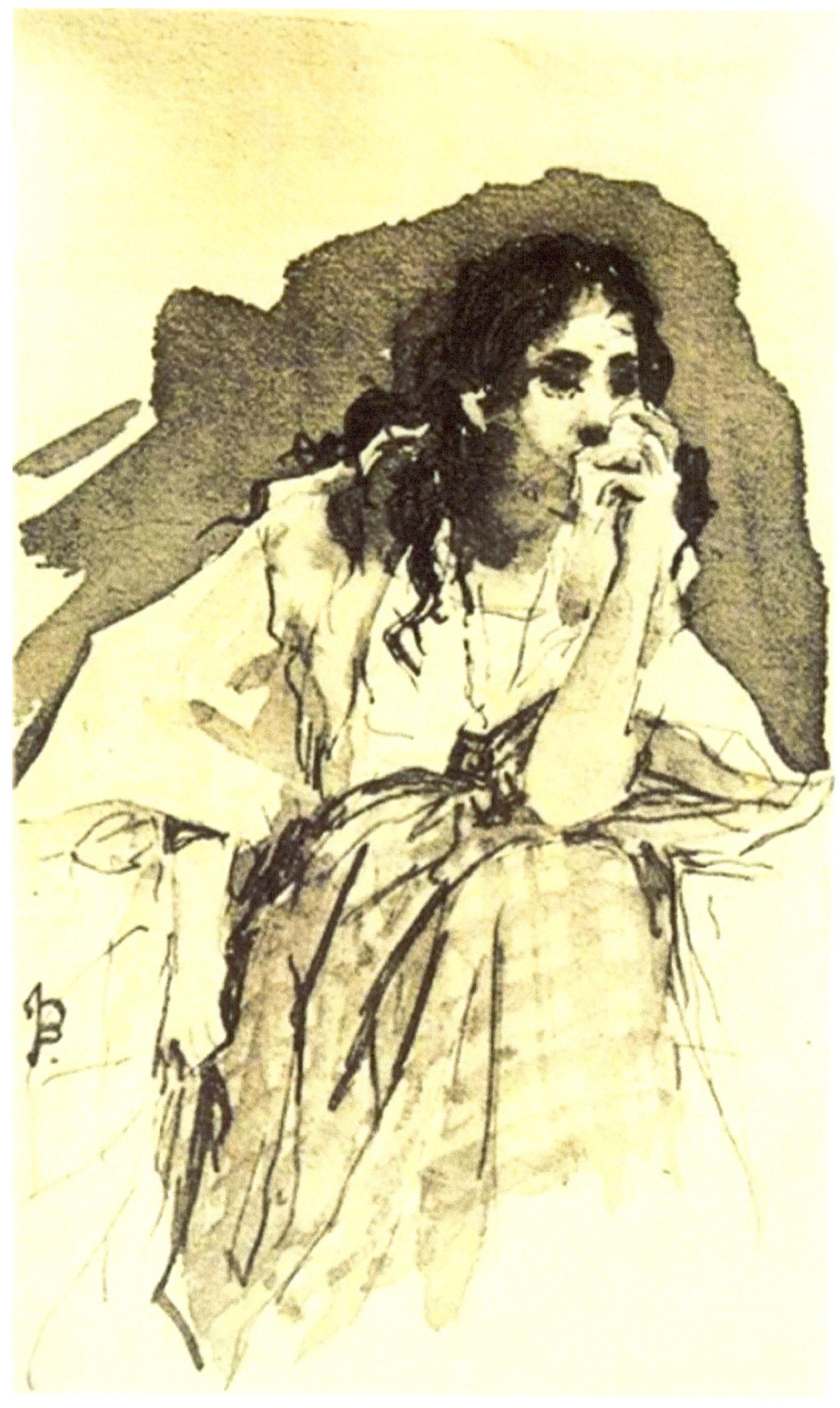

Maria Clara portrait by Juan Luna, 1890s, gift to Jose Rizal for his Noli Me Tangere, courtesy of Phils My Phils at facebook

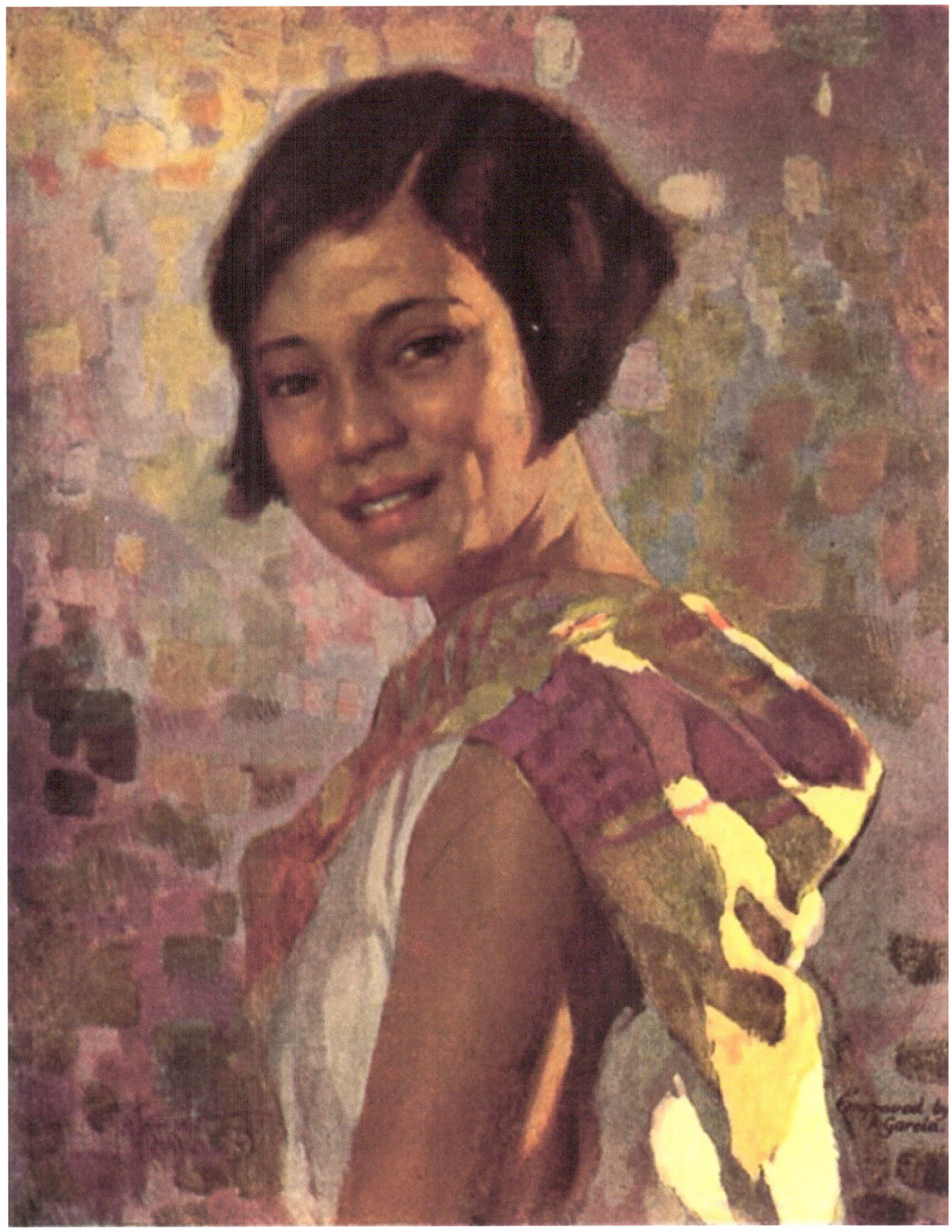

Modern Manila Girl, in oil, by Fernando Amorsolo, used as cover in Phil. Magazines, 1928-29 – courtesy of Edgar O. Cruz, facebook

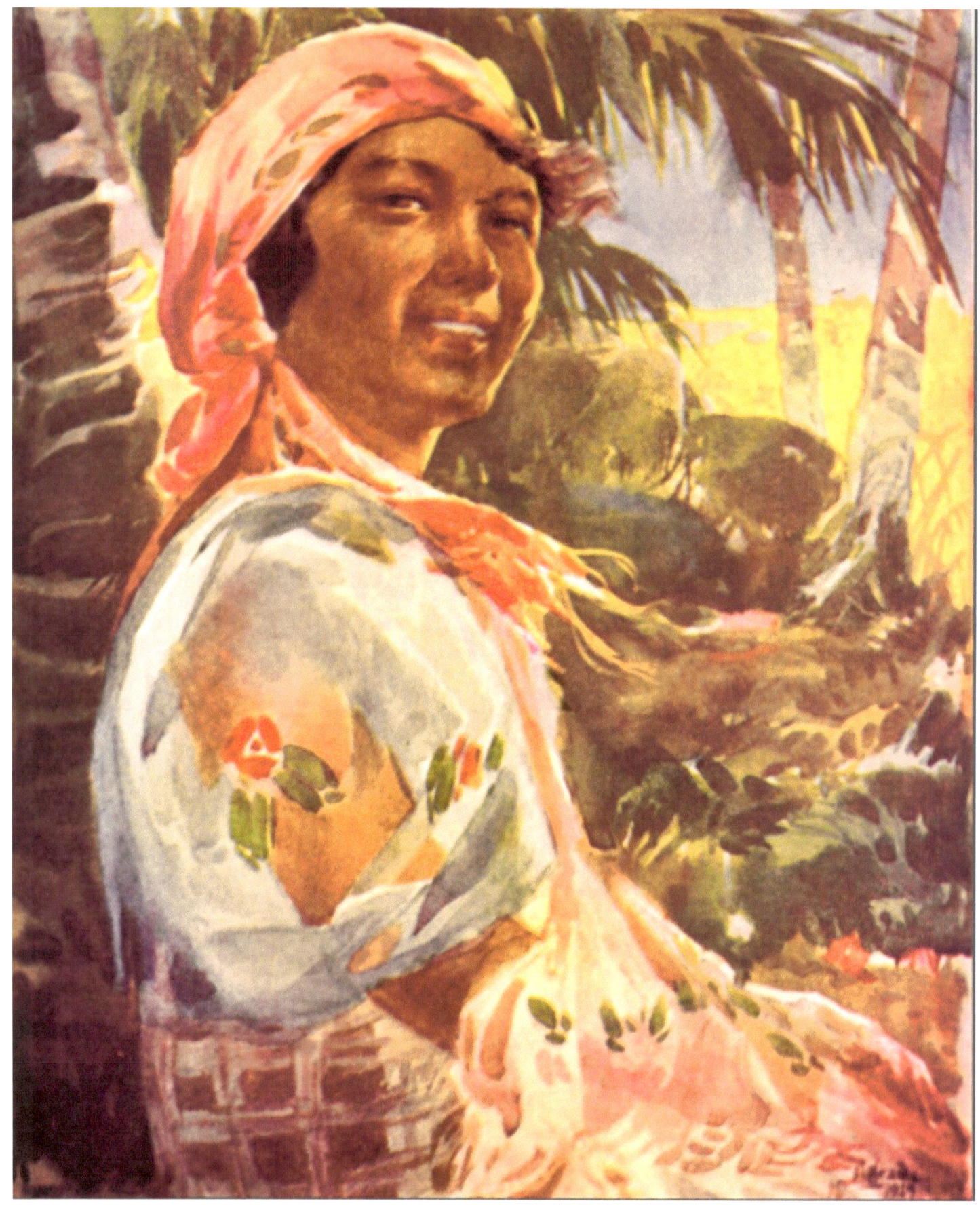

Bisaya Girl, water color by I.L.Miranda, circa 1928-29, used in cover Of Phil. Magazine – courtesy of Edgar O. Cruz, facebook

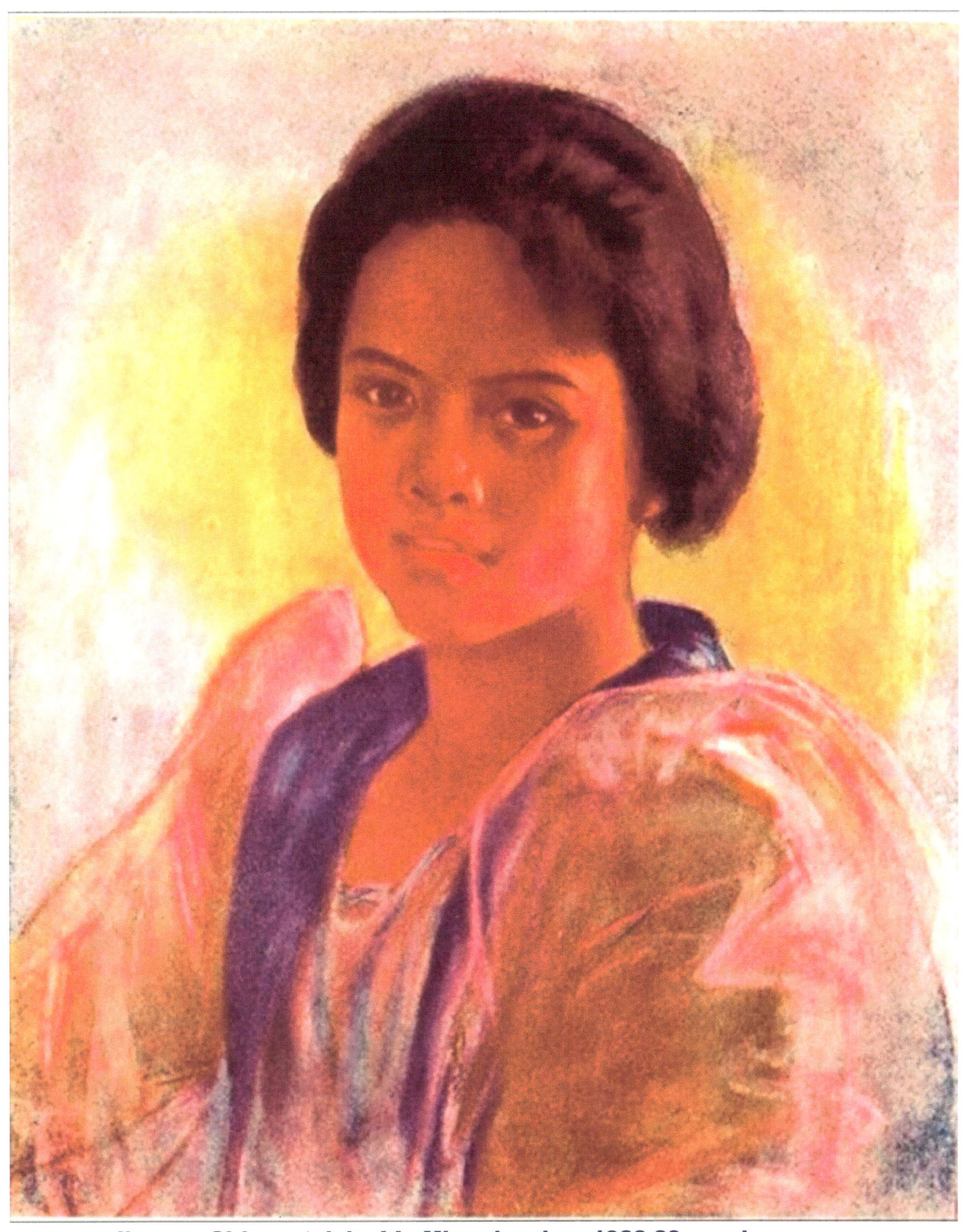

Ilocano Girl, pastel, by I.L. Miranda, circa 1928-29, used as cover in Phil. Magazine. – courtesy of Edgar O. Cruz, facebook

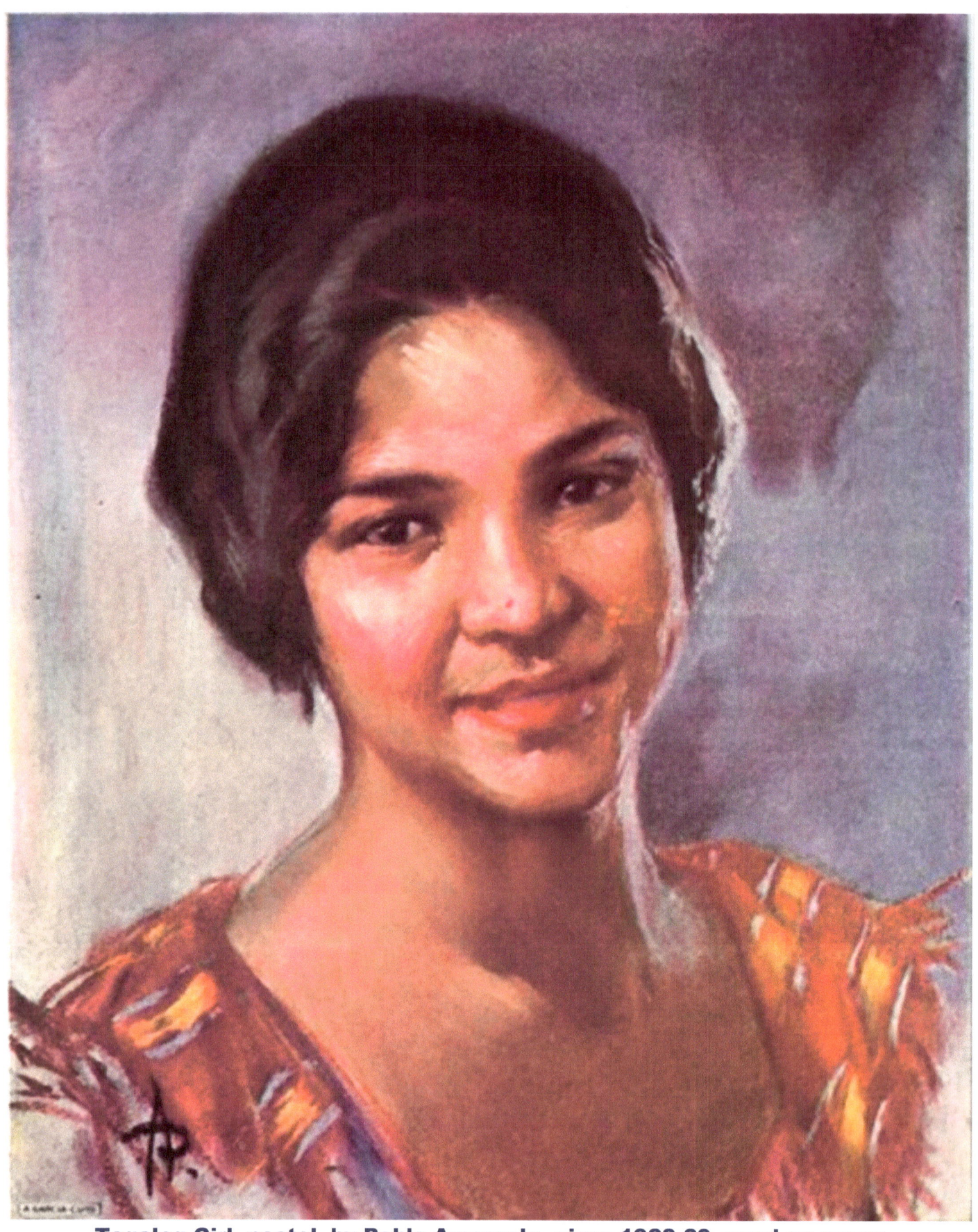

Tagalog Girl, pastel, by Pablo Amorsolo, circa 1928-29, used as cover in Phil. Magazine. – courtesy of Edgar O. Cruz, facebook

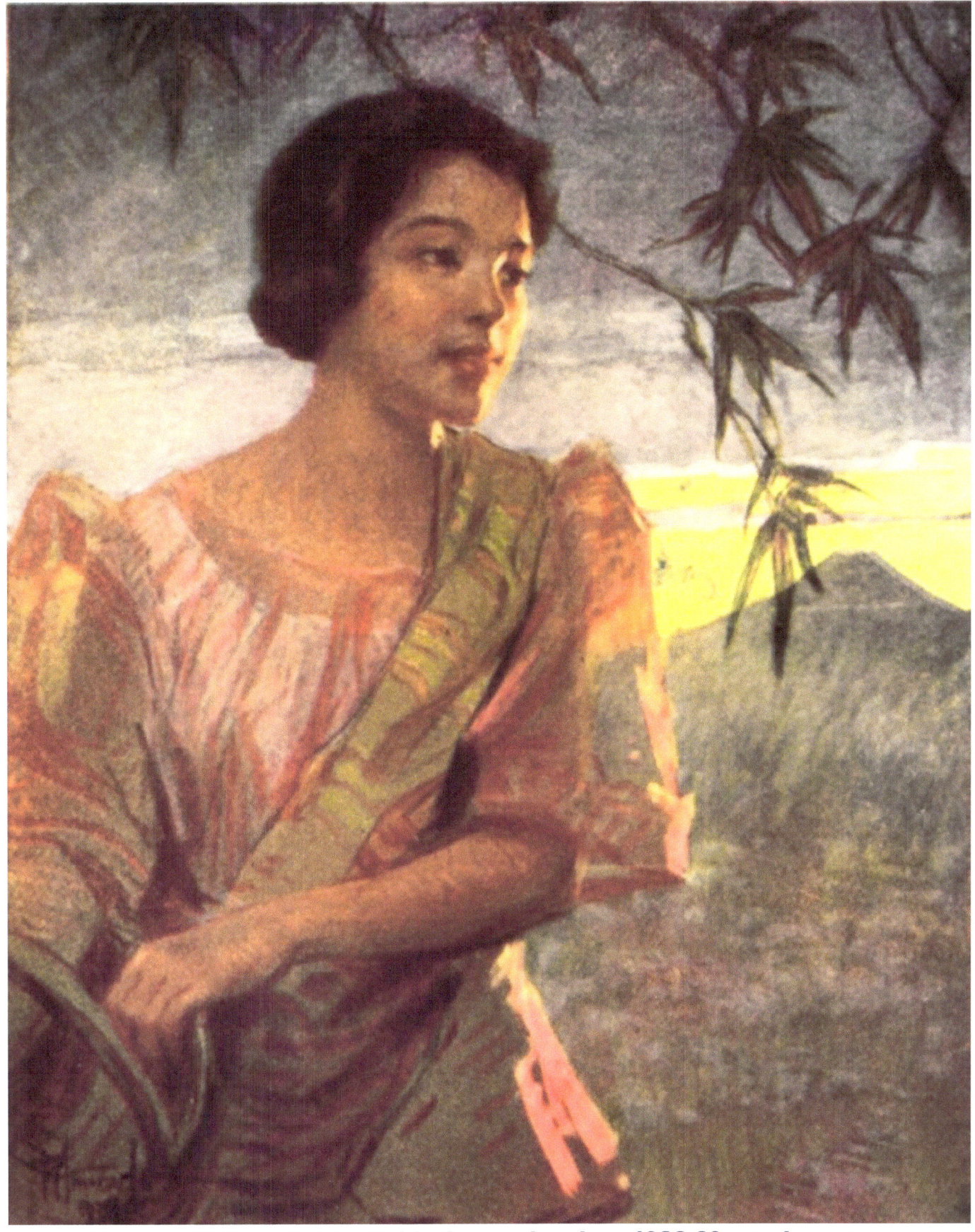

Bicolana Girl, pastel, by Pablo Amorsolo, circa 1928-29, used as cover In Phil. Magazine. – courtesy of Edgar O. Cruz, facebook

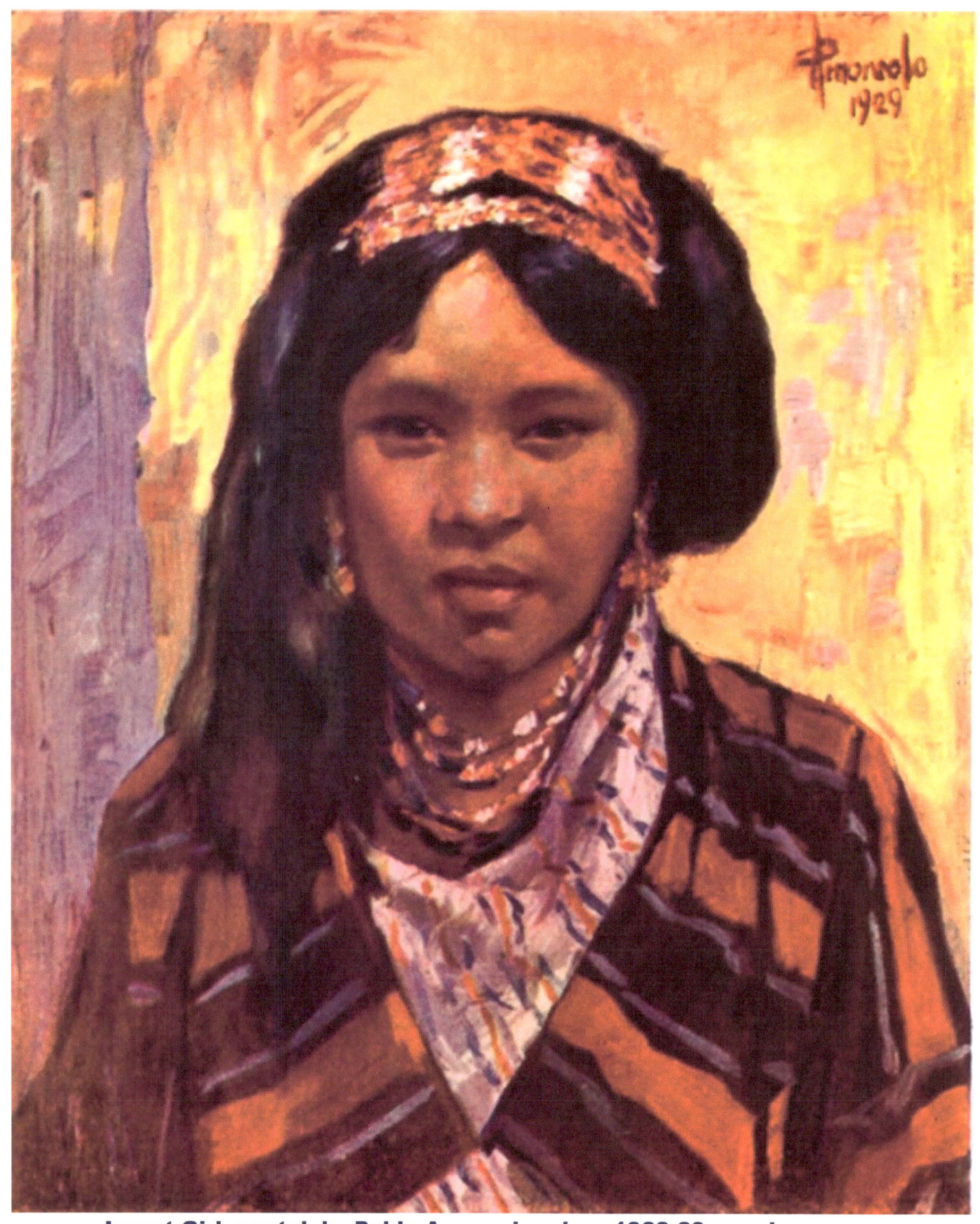

Igorot Girl, pastel, by Pablo Amorsolo, circa 1928-29, used as cover In Phil. Magazine. – courtesy of Edgar O. Cruz, facebook

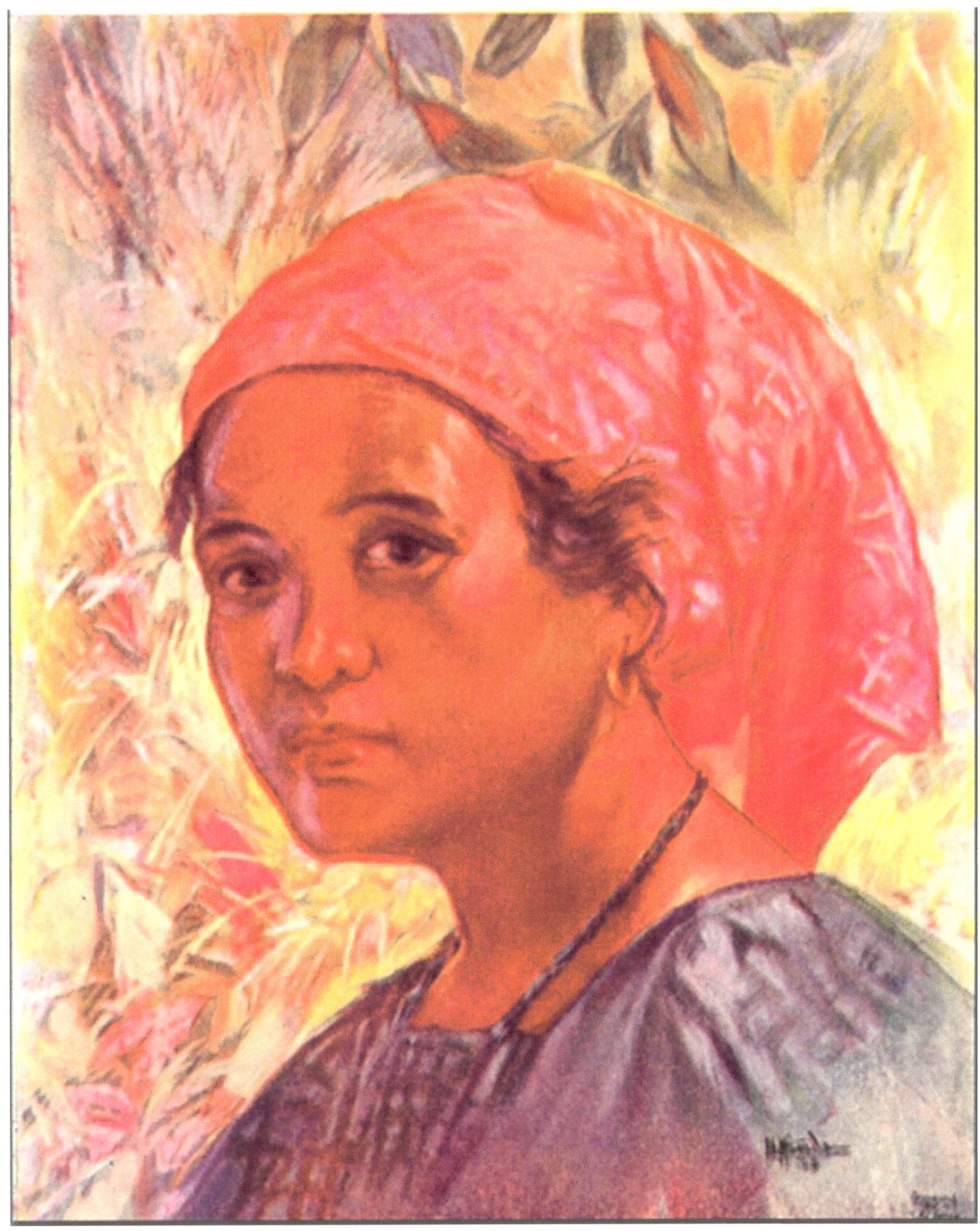
Mandaya Girl, water color, by I.L. Miranda, circa 1928-29, used as cover In Phil. Magazine. – courtesy of Edgar O. Cruz, facebook

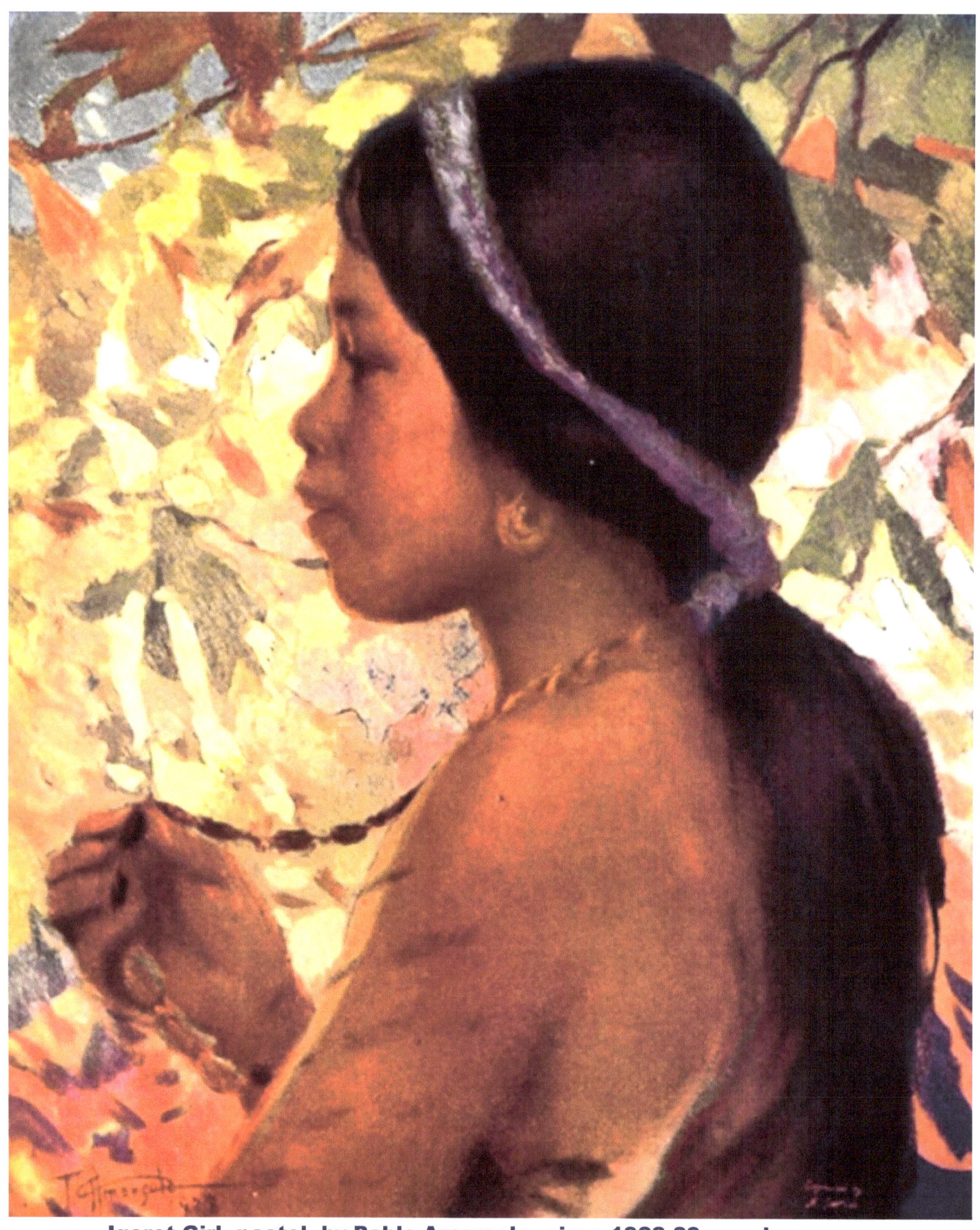

Igorot Girl, pastel, by Pablo Amorsolo, circa 1928-29, used as cover In Phil. Magazine. – courtesy of Edgar O. Cruz, facebook

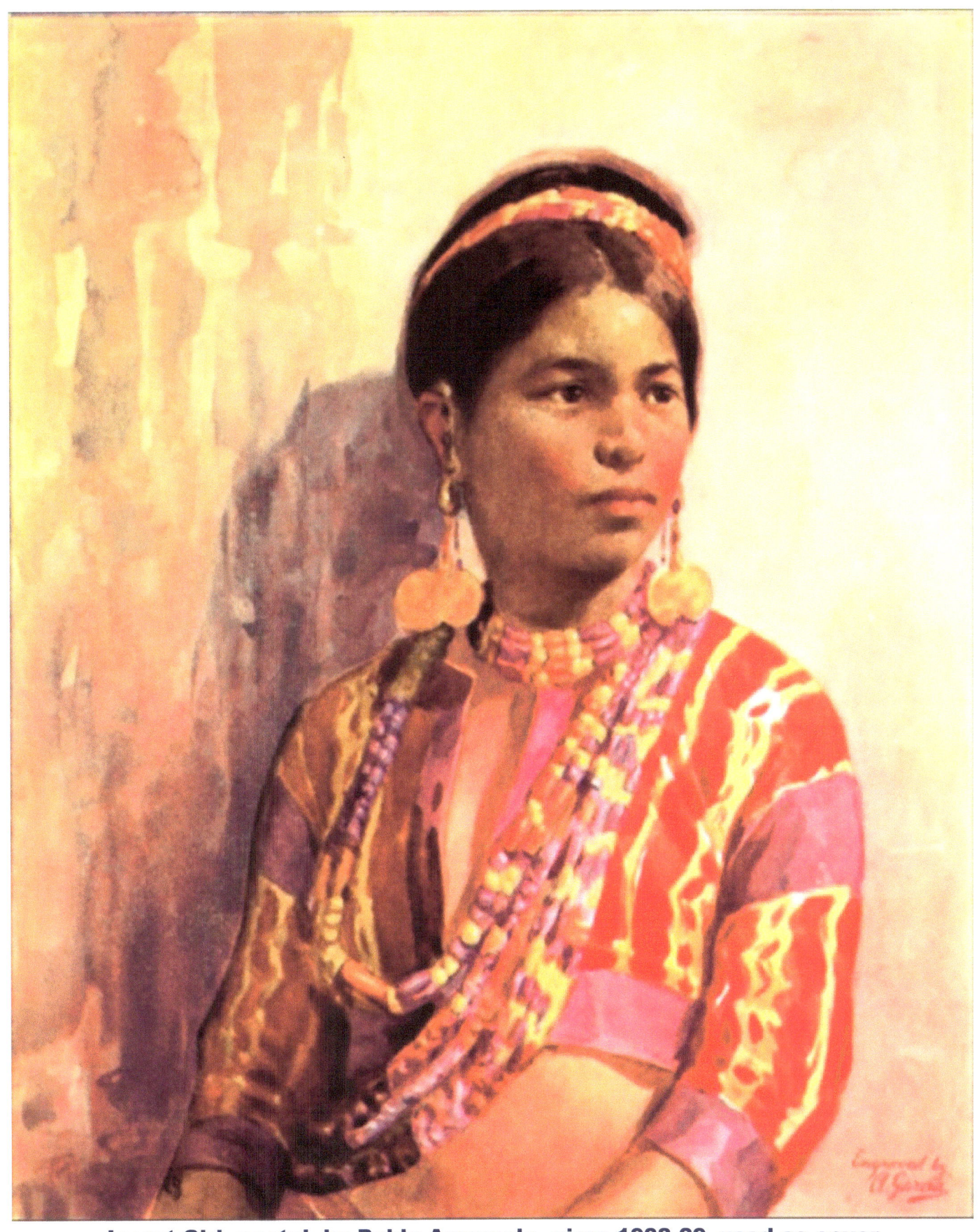

Igorot Girl, pastel, by Pablo Amorsolo, circa 1928-29, used as cover In Phil. Magazine. – courtesy of Edgar O. Cruz, facebook

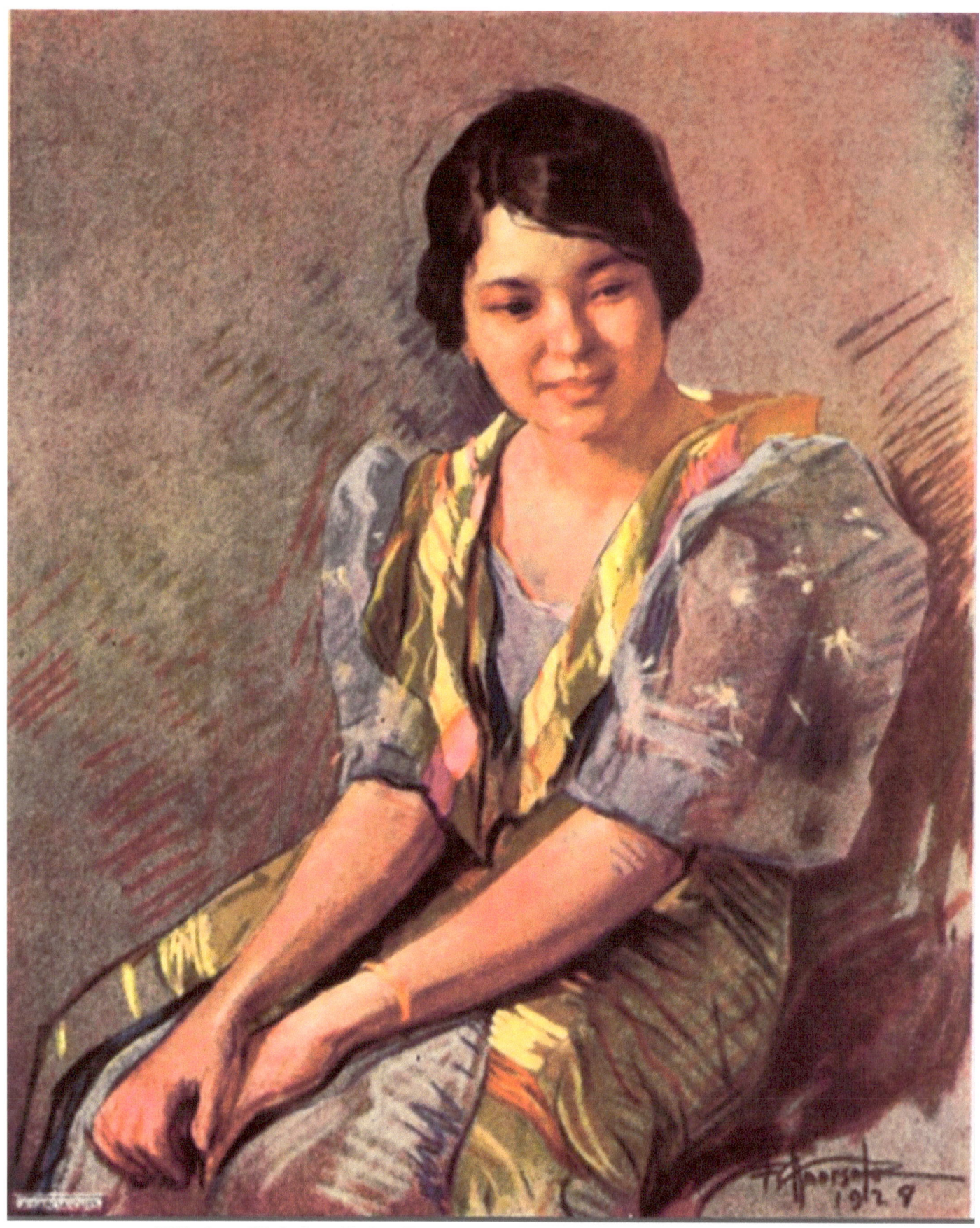

Filipina Girl, in oil, by Fernando Amorsolo, used as cover in Phil. Magazines, 1928-29 – courtesy of Edgar O. Cruz, faceboo

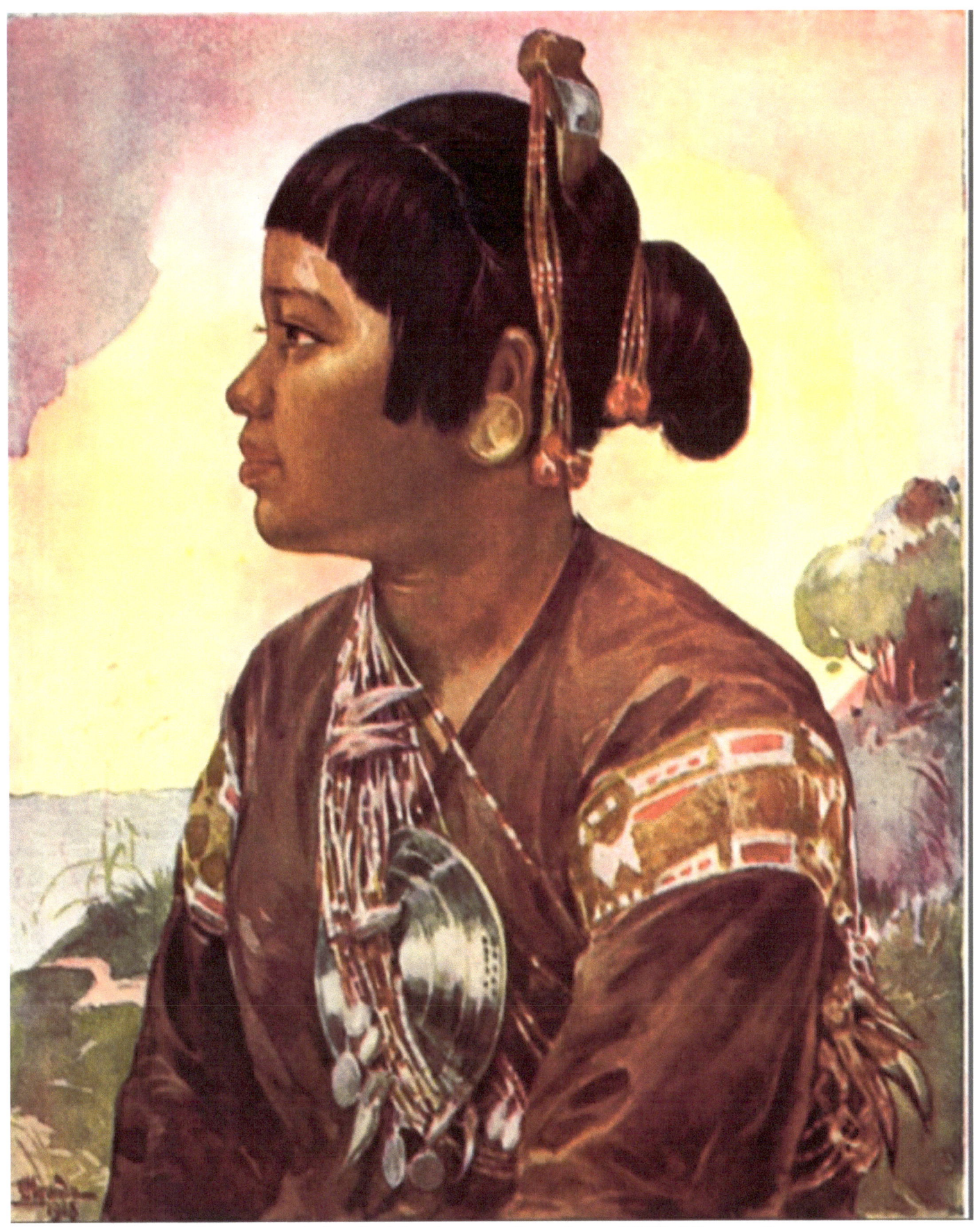
Igorot Girl, pastel, by Pablo Amorsolo, circa 1928-29, used as cover in Phil. Magazine. – courtesy of Edgar O. Cruz, facebook

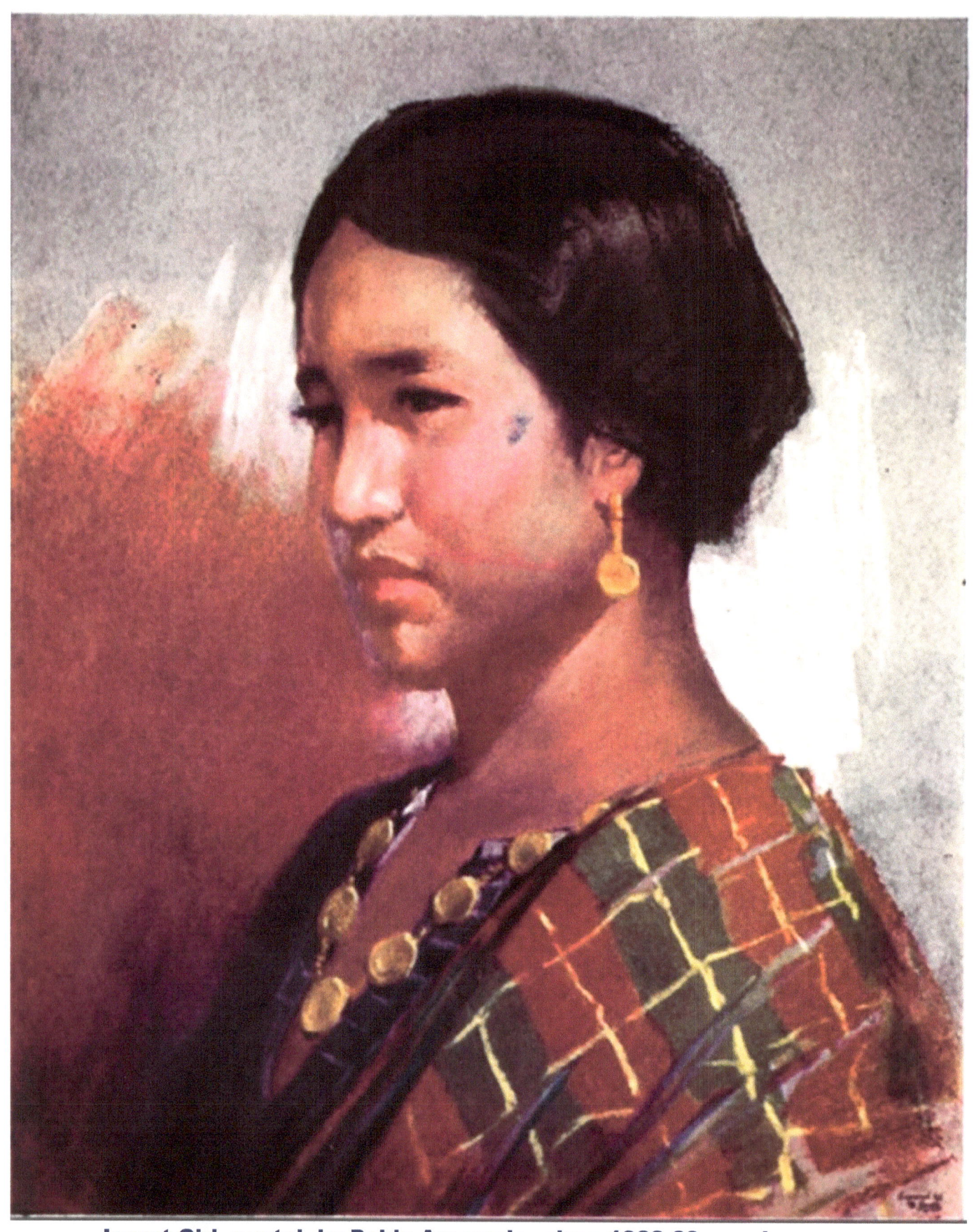

Igorot Girl, pastel, by Pablo Amorsolo, circa 1928-29, used as cover In Phil. Magazine. – courtesy of Edgar O. Cruz, facebook

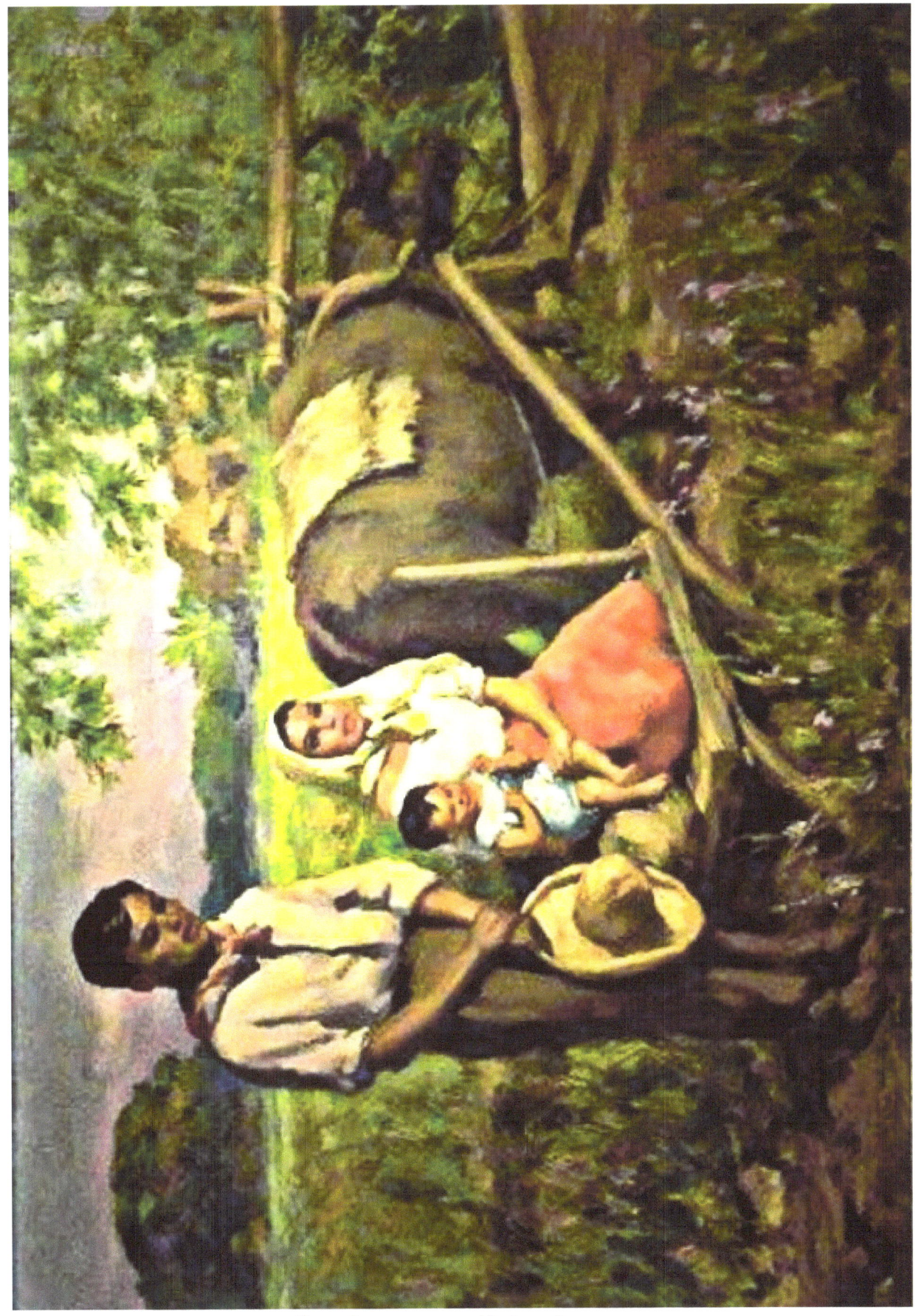
Rural scene, artist unknown

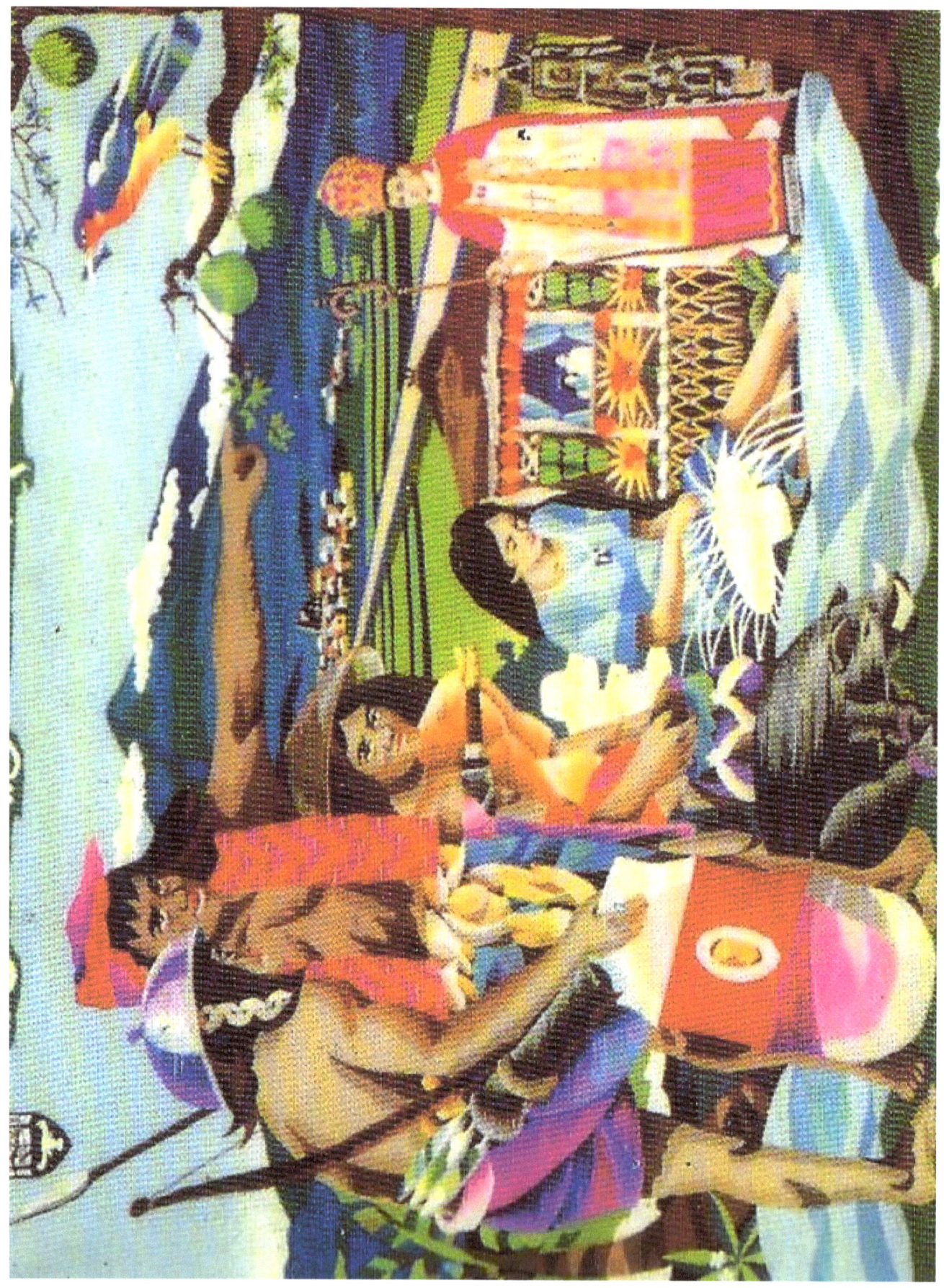
Spread of Christianity, artist unknown

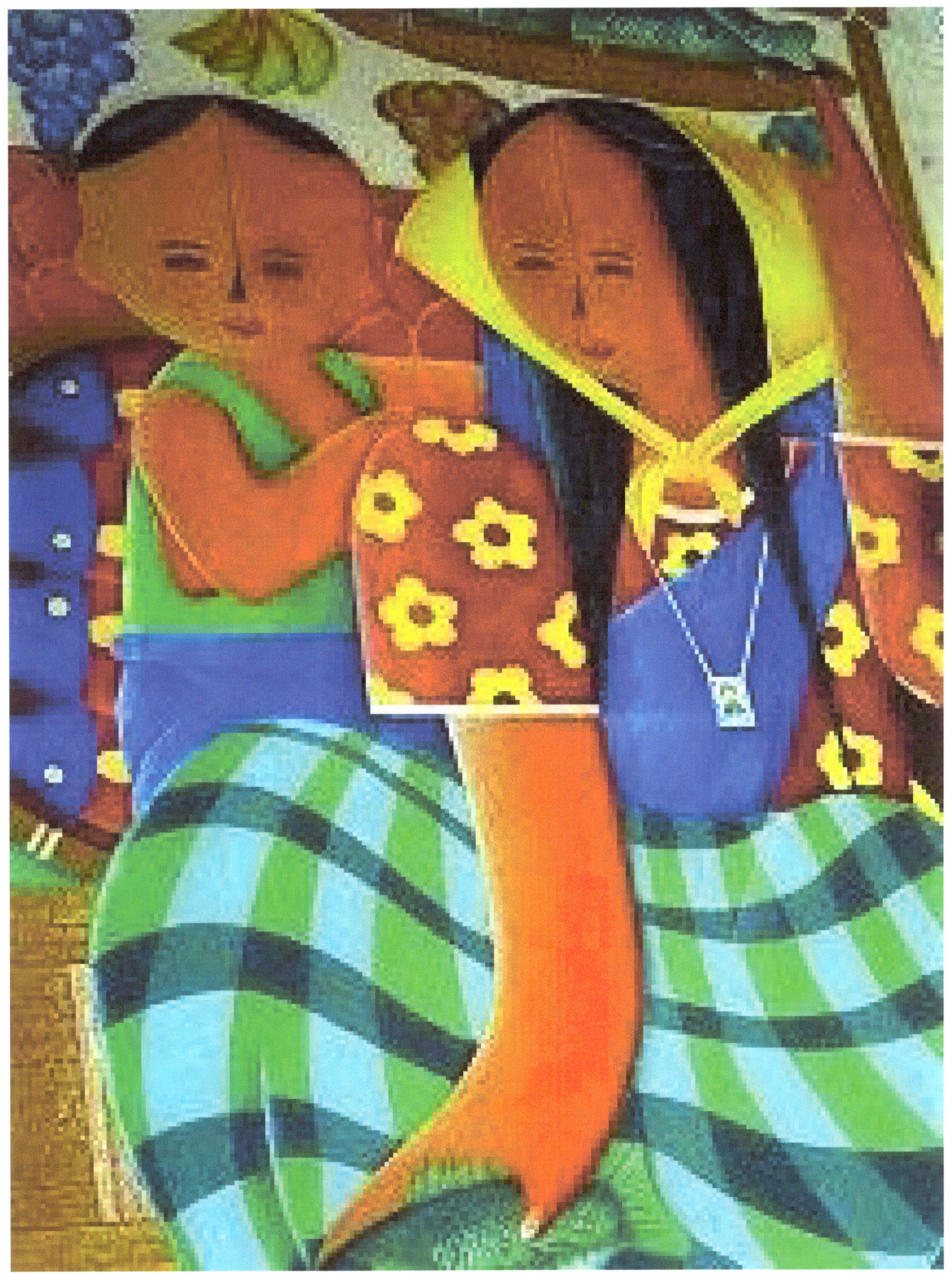
Abstract painting, artist unknown

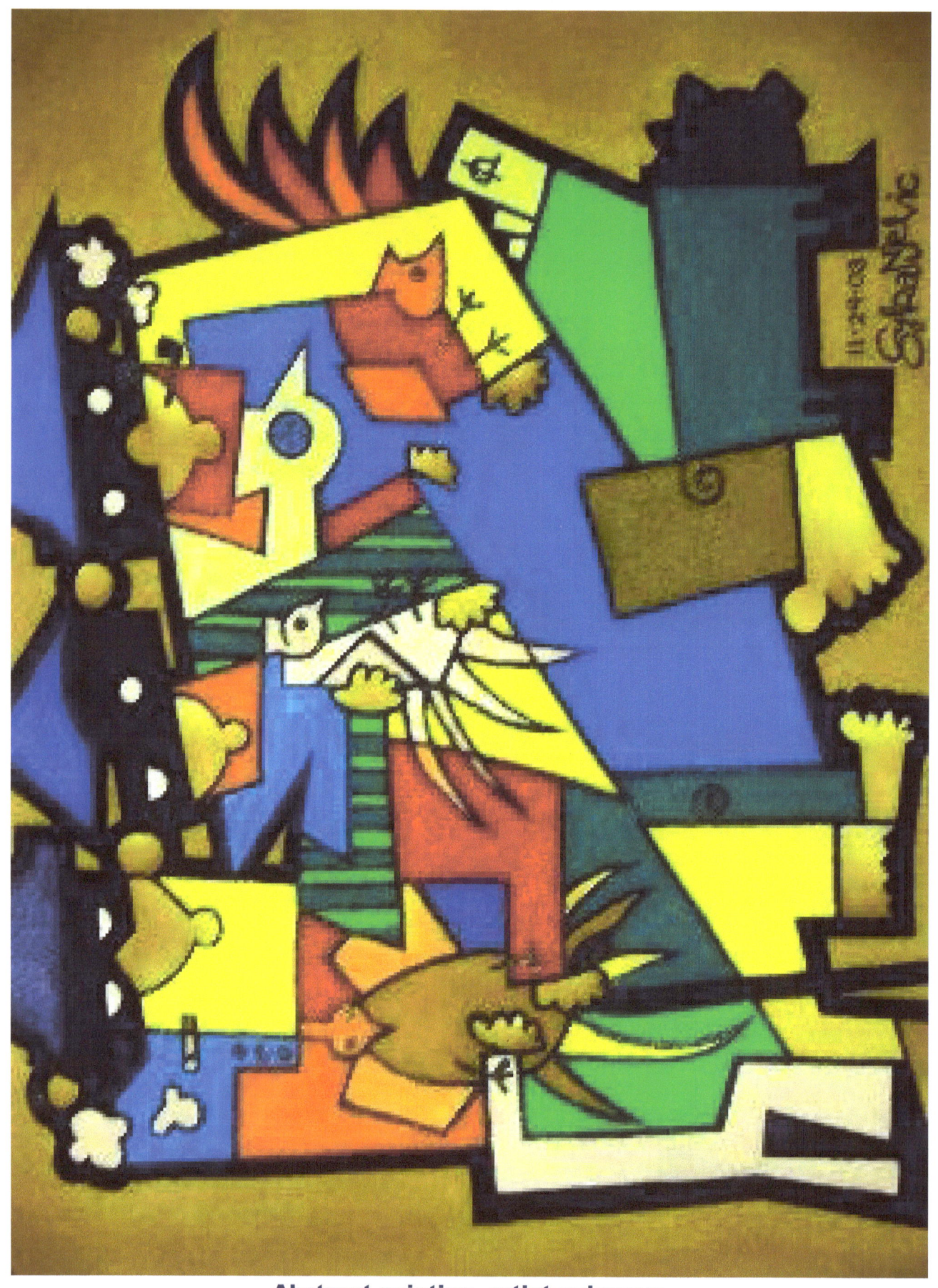

Abstract painting, artist unknown

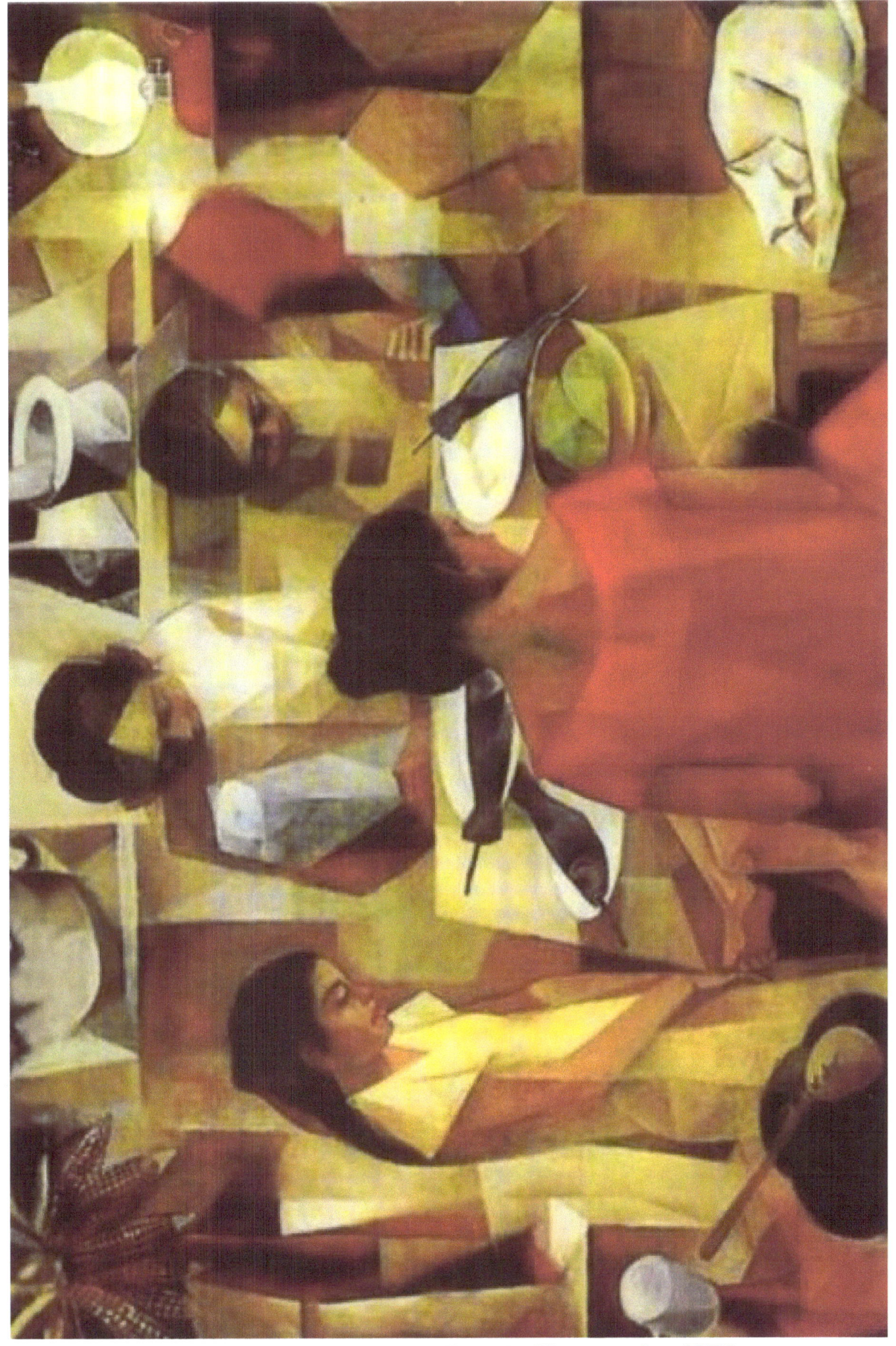
Grace before meals by Vicente Manansala, 1970s

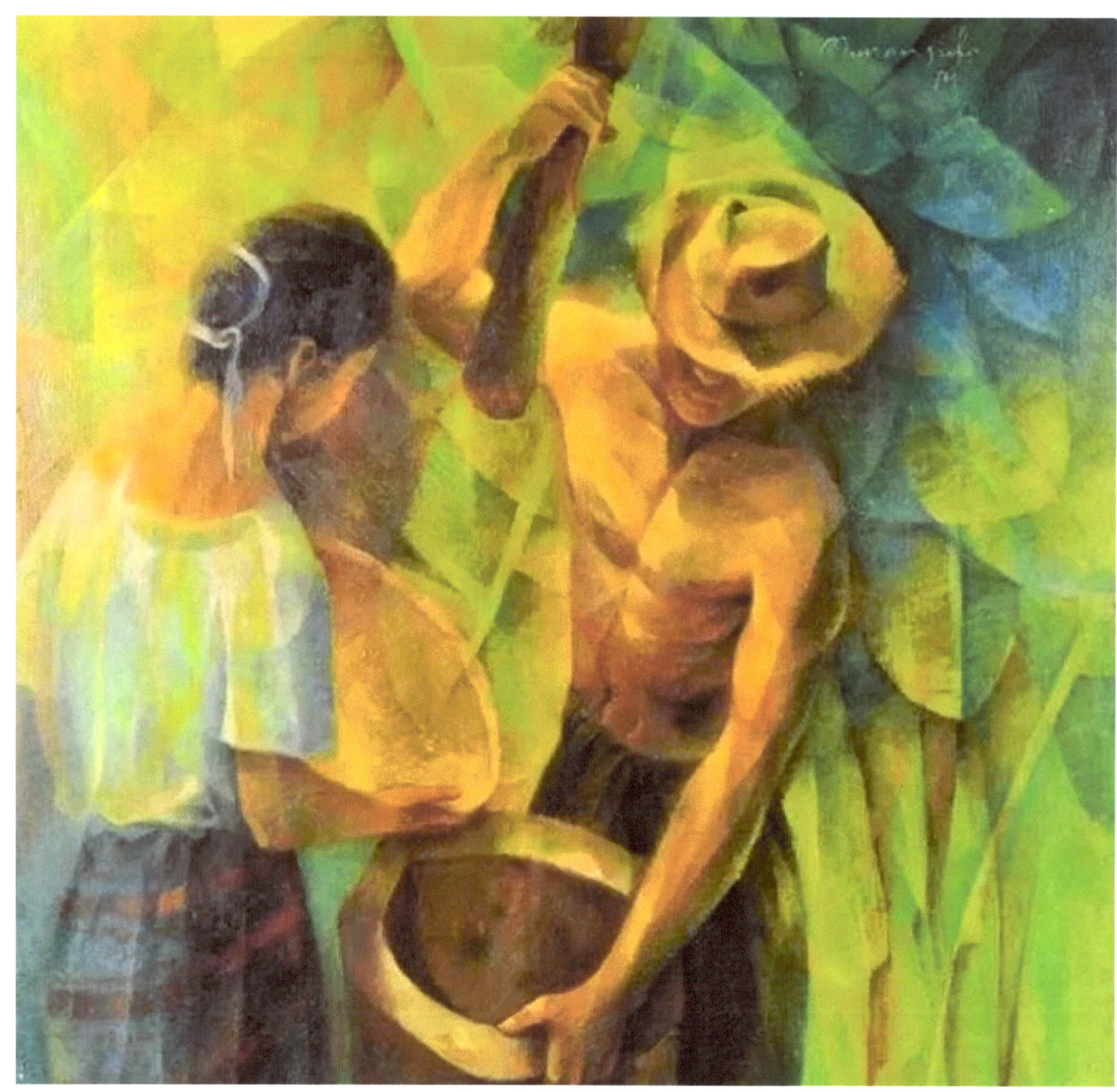

Magbabayo, pounding rice, by Vicente Manansala, 1970s

WELCOME! We hope you enjoy this Fave Art-12 album collection of favorite paintings (classic and modern). Most are copied from the internet, posters, prints and books. You may display this book as coffee table book in your living room, as conversation piece. You may give this as gift. You may cut out and frame each page. Each work is 8.5x11 inches and suitable for framing, and for wall decors.

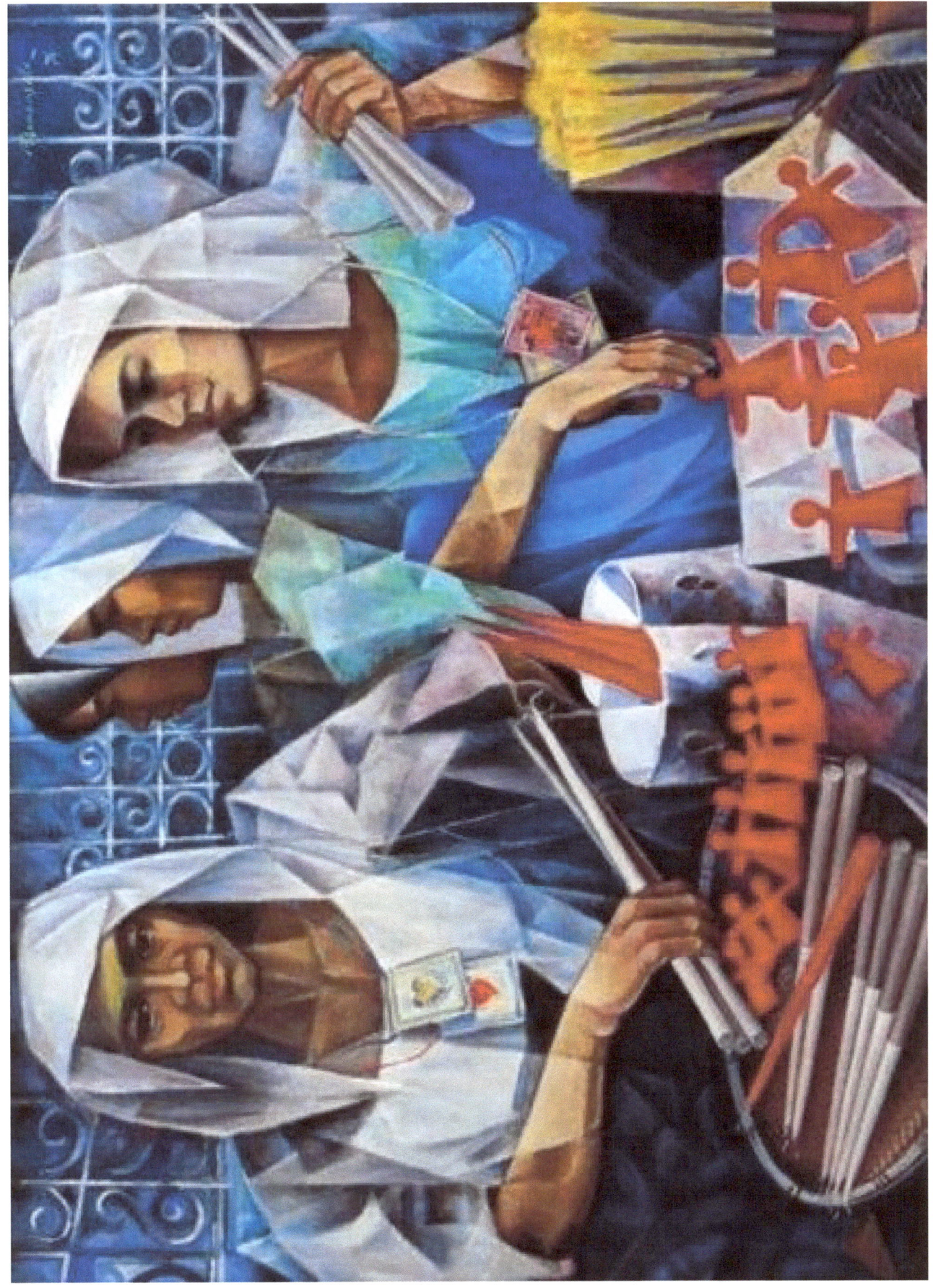
Candle Vendors, by Vicente Manansala, 1970s

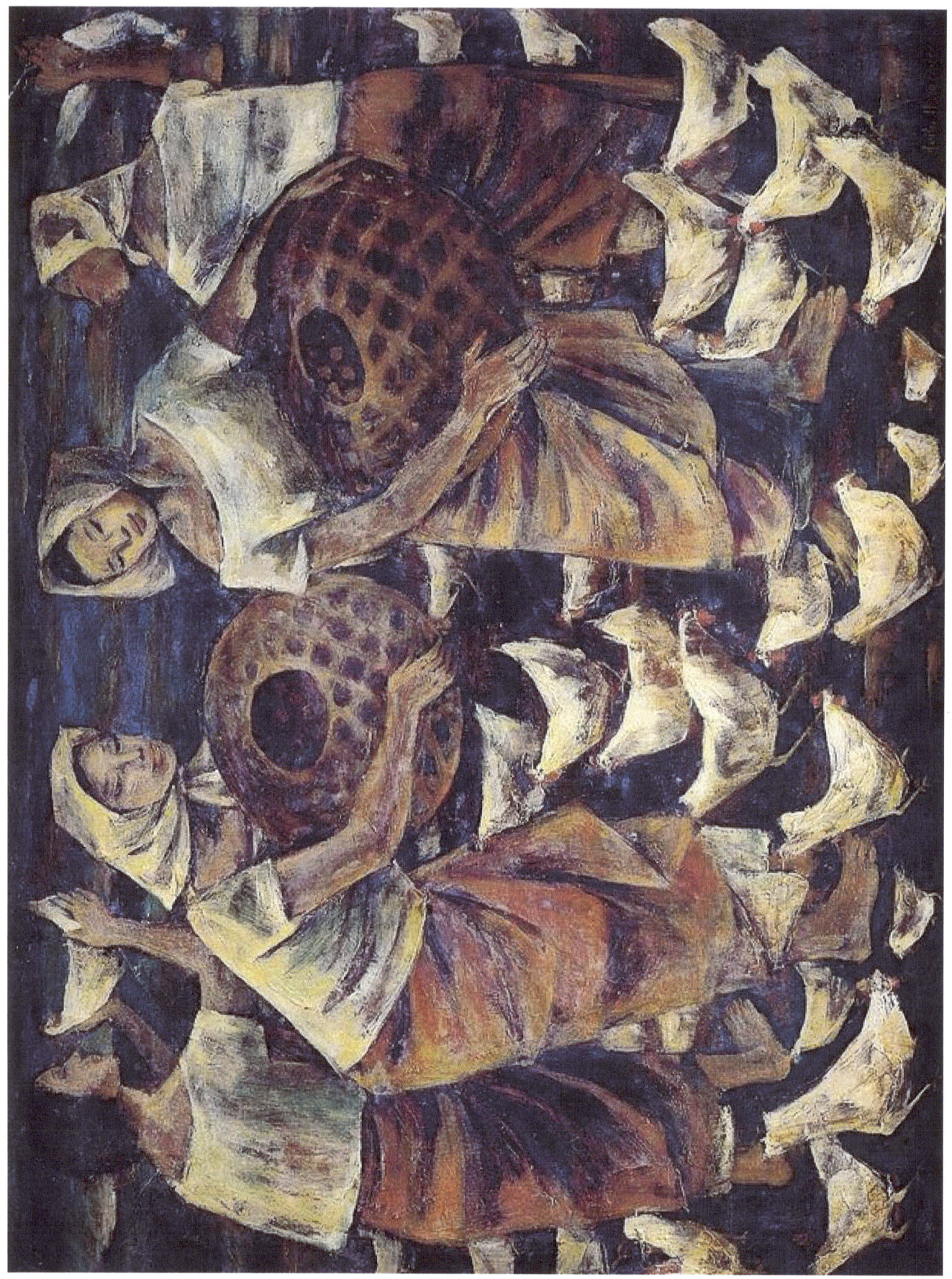
Catching Fish by Anita Magsaysay-Ho, 1970s

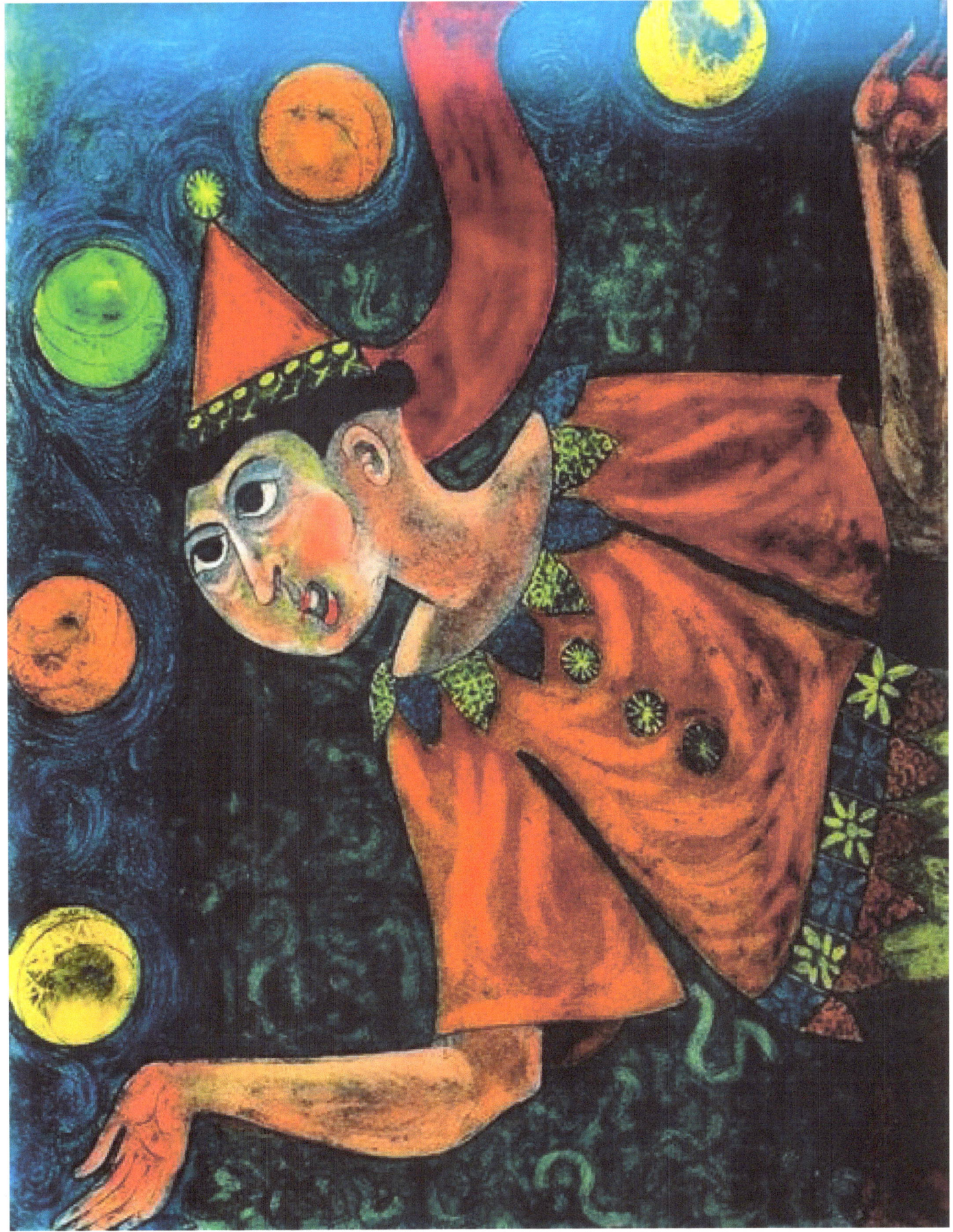

By Manuel Rodriguez, age 99 in 2017, foremost Philippine Printmaker

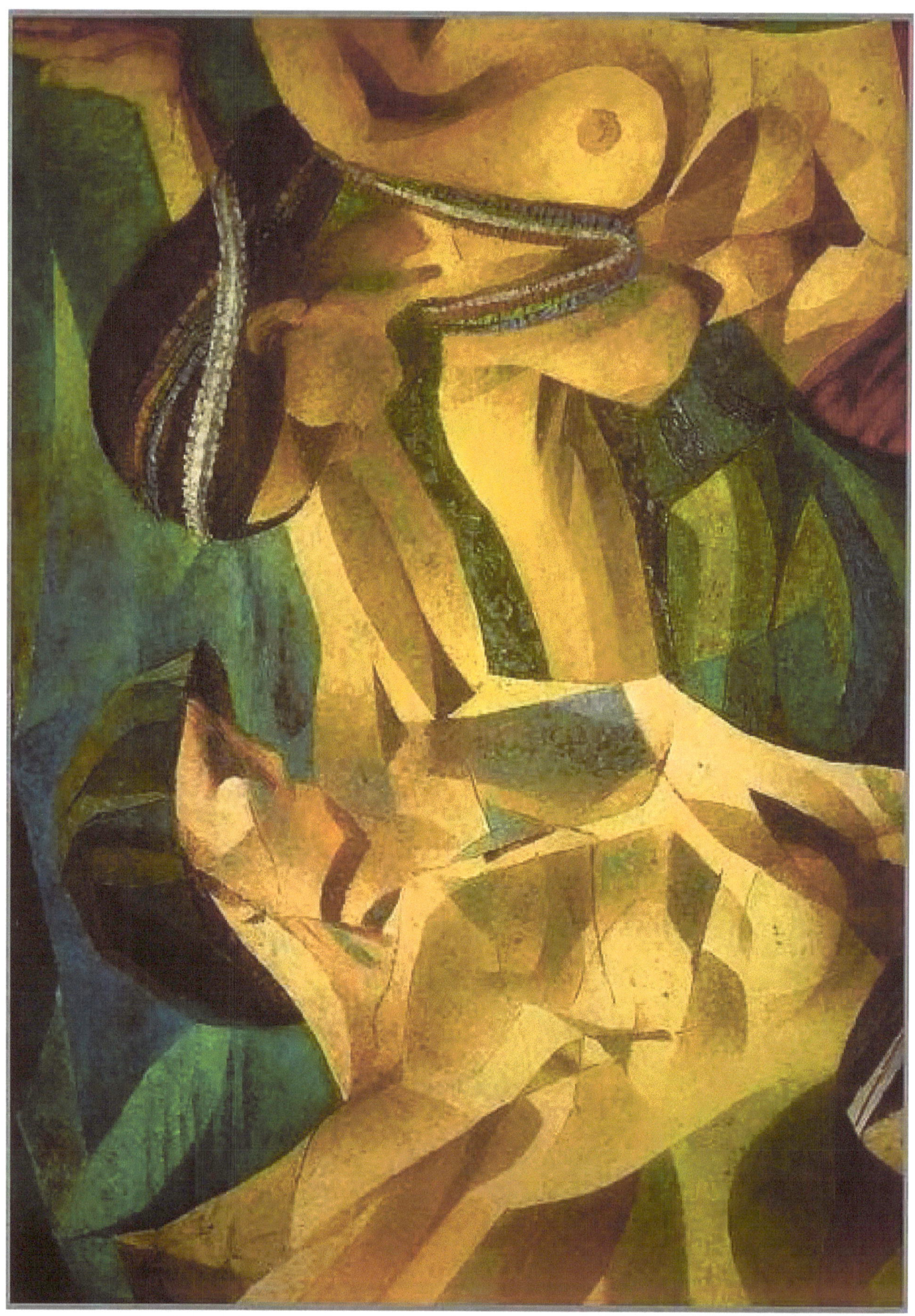

By Cesar Legaspi, another famous Pinoy Painter, 1980s

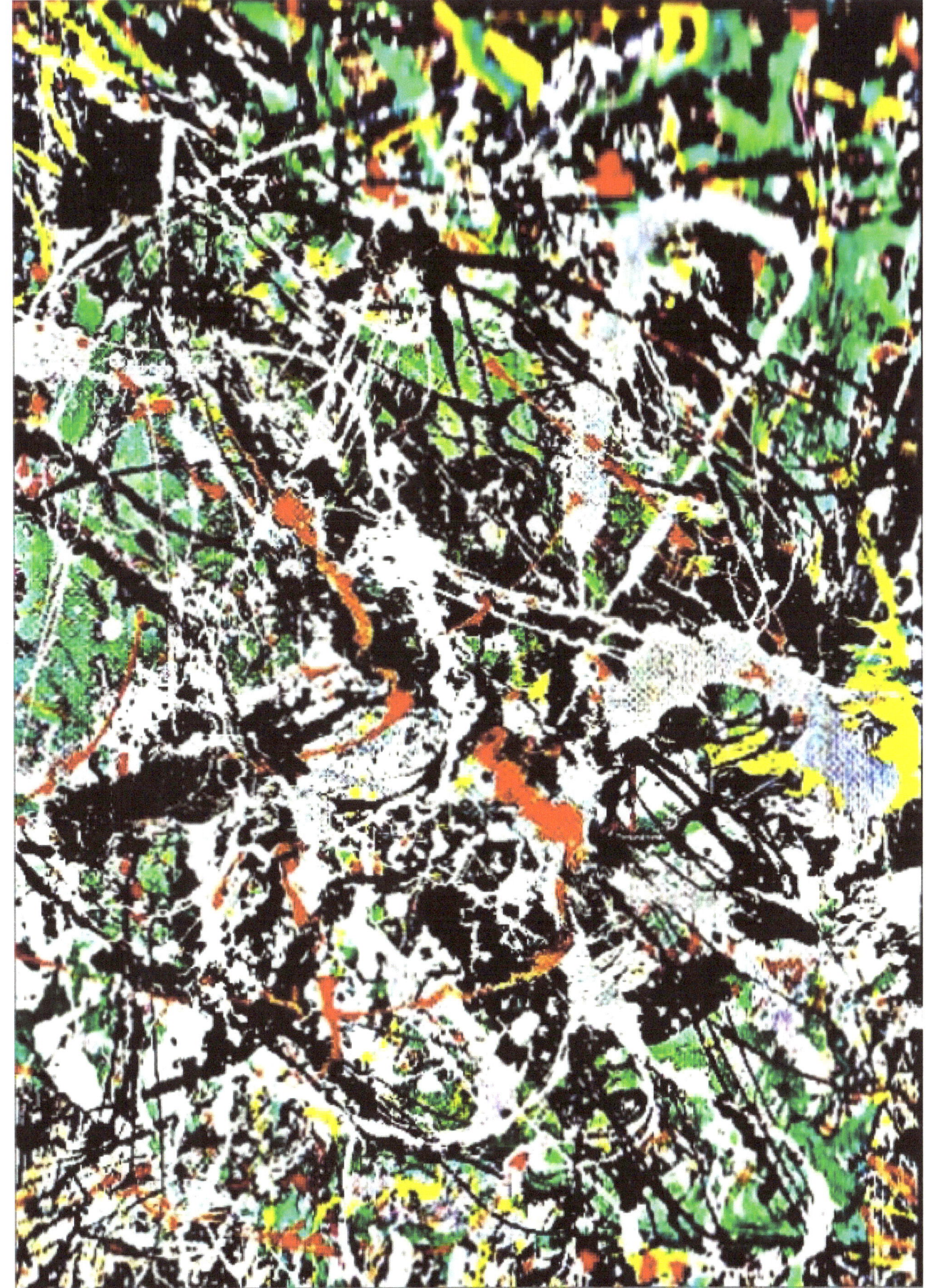
By Jackson Pollock, 1949, Untitled, Green Silver (priceless)

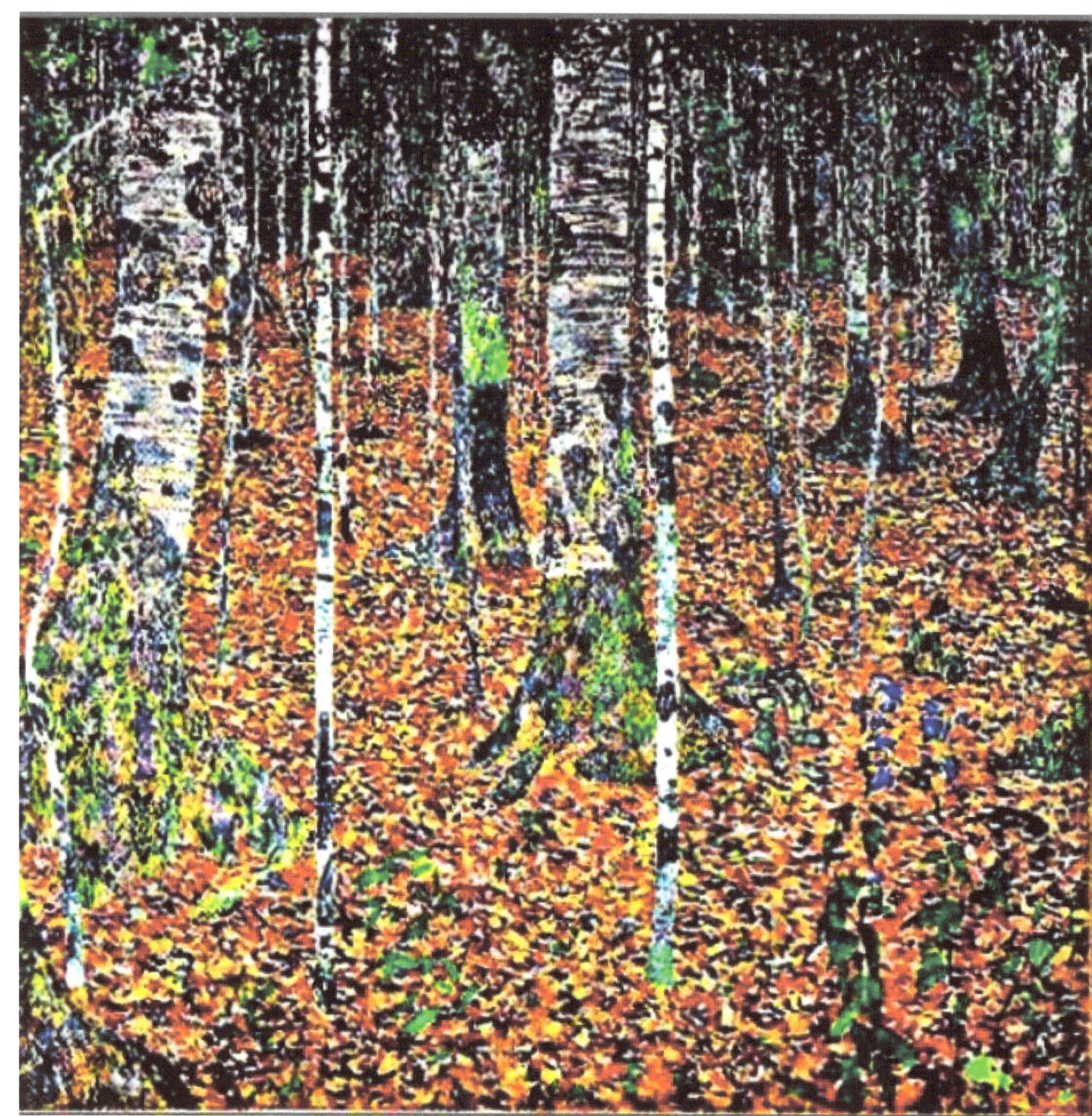

By Gustav Klimt, 1903, Birch Tree (famous)

WELCOME! We hope you enjoy this Fave Art-12 album collection of favorite paintings (classic & modern). Most are copied from the internet, posters, prints and books. You may display this book as coffee table book in your living room, as conversation piece. You may give this as gift. You may cut out and frame each page. Each work is 8.5x11 inches and suitable for framing, and for wall decors.

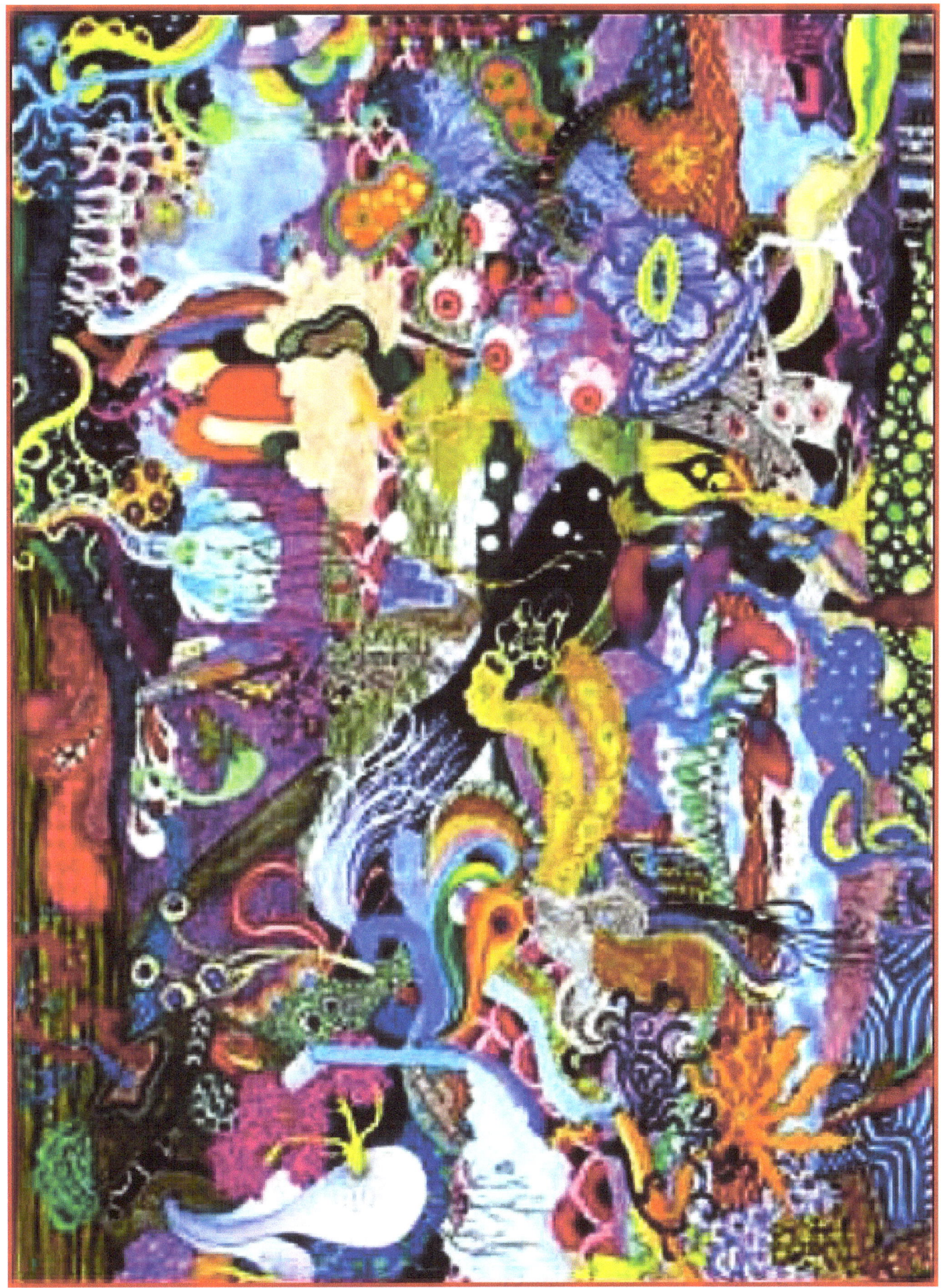
Lubay. Modernitistic, by Candelaria (Pinoy painter)

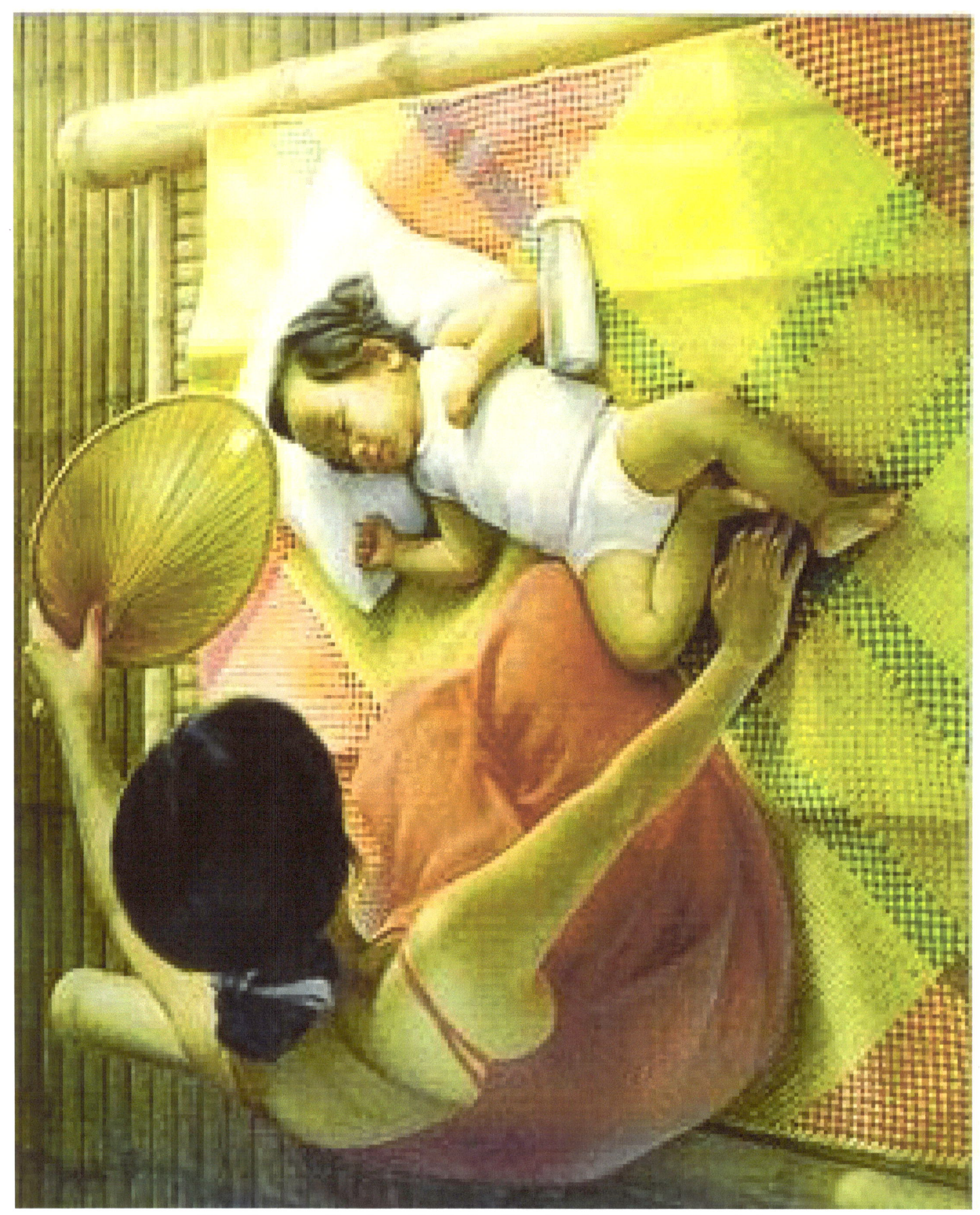

Mag-ina sa Banig, 1960, by Nestor Leynes (classic)

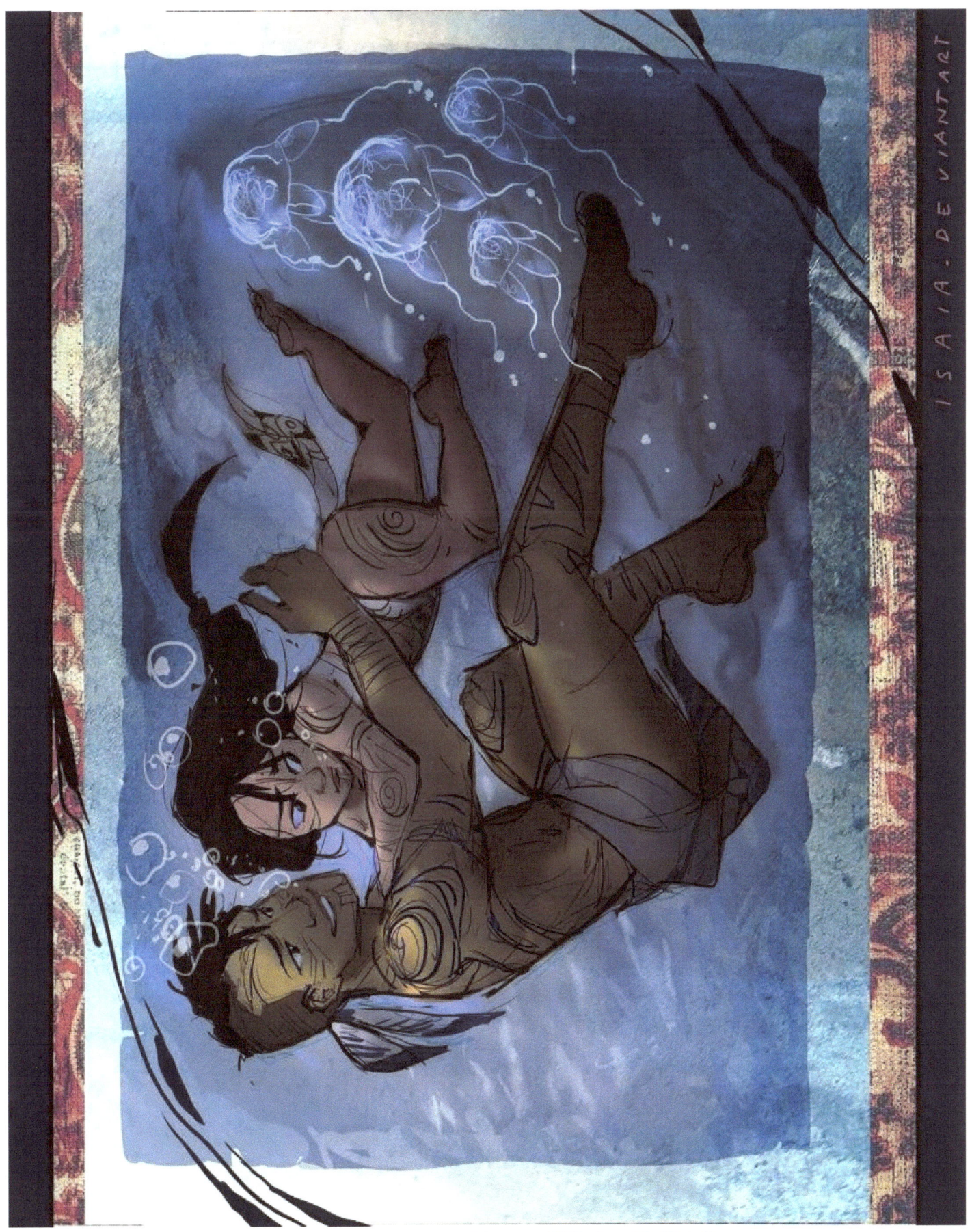

By Isaia, Deviant Art, Disney Filipino Folktale

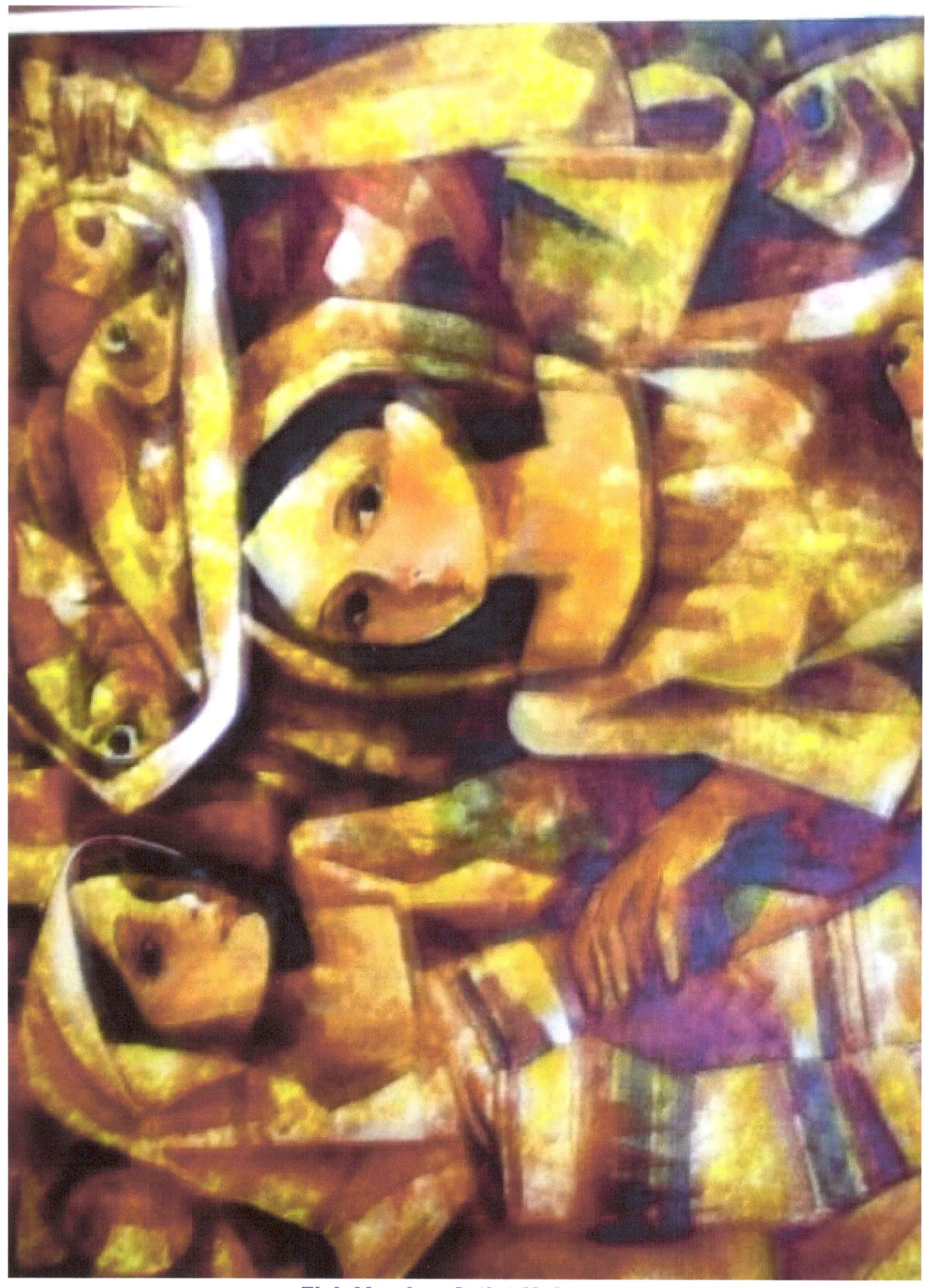

Fish Vendor, Artist Unknown

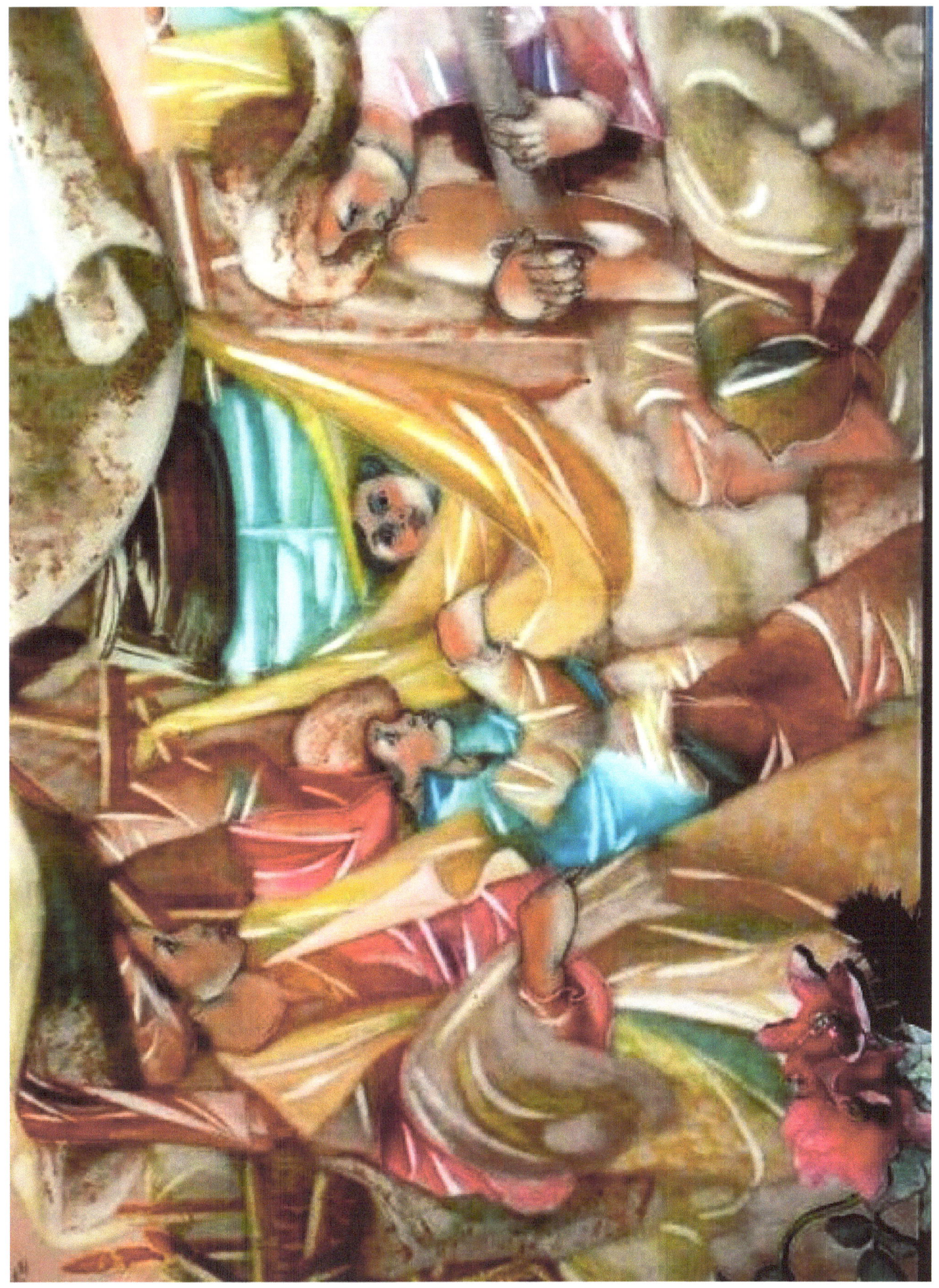

Family Relaxing, artist unknown

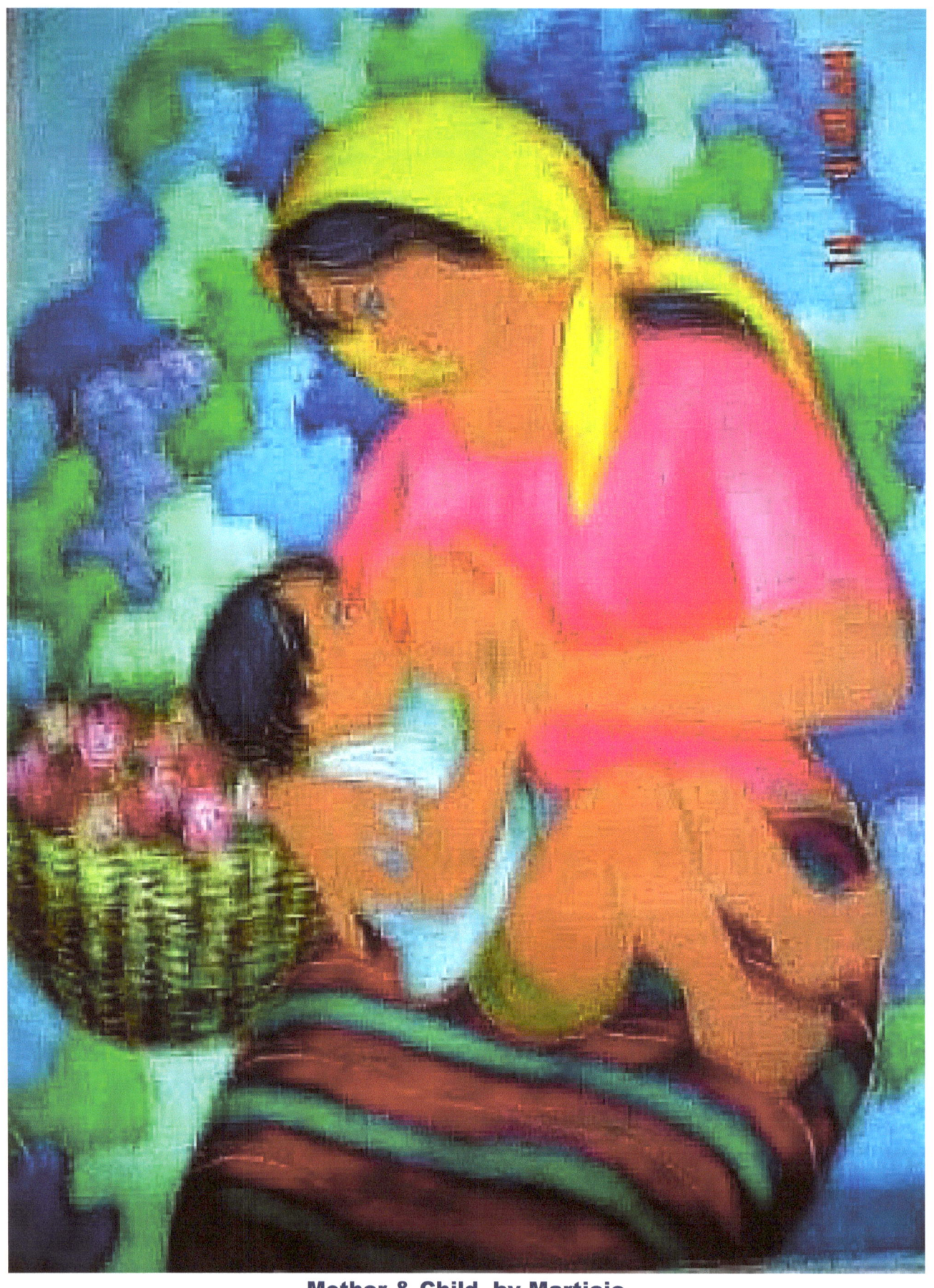
Mother & Child, by Marticio

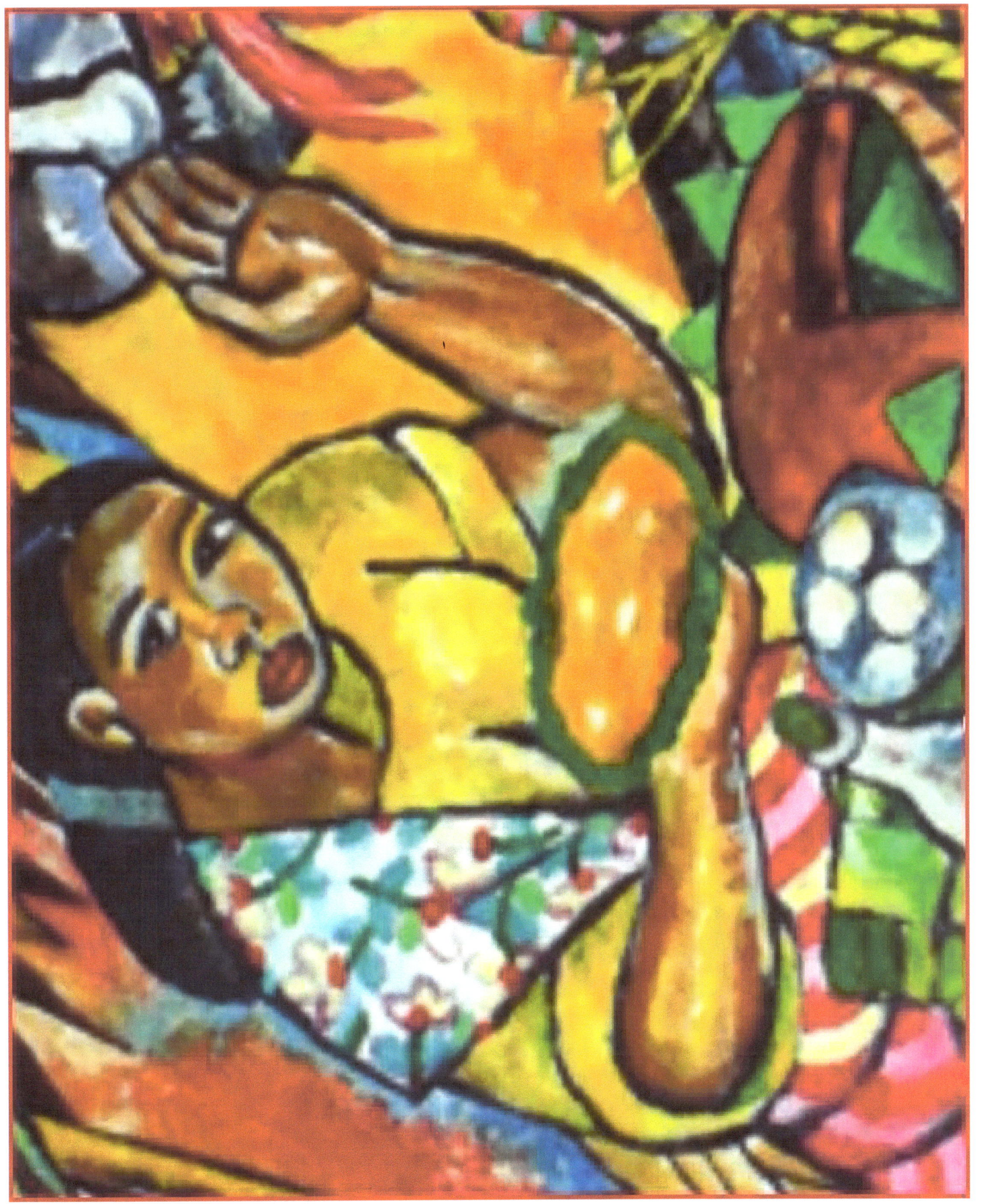
Bibingca or Rica Cake, Artist unknown

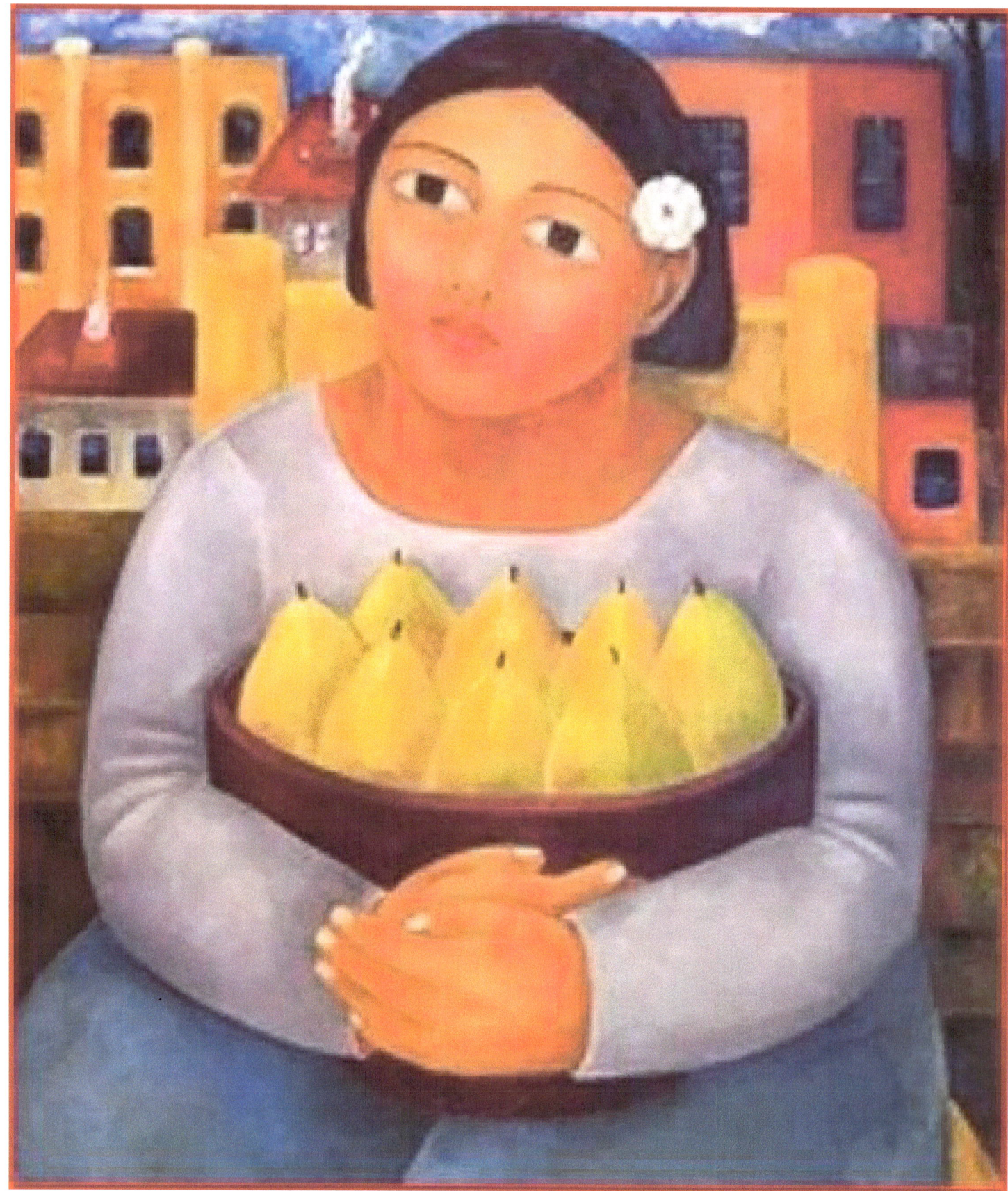

Fruit Vendor, modernistic, Artist unknown

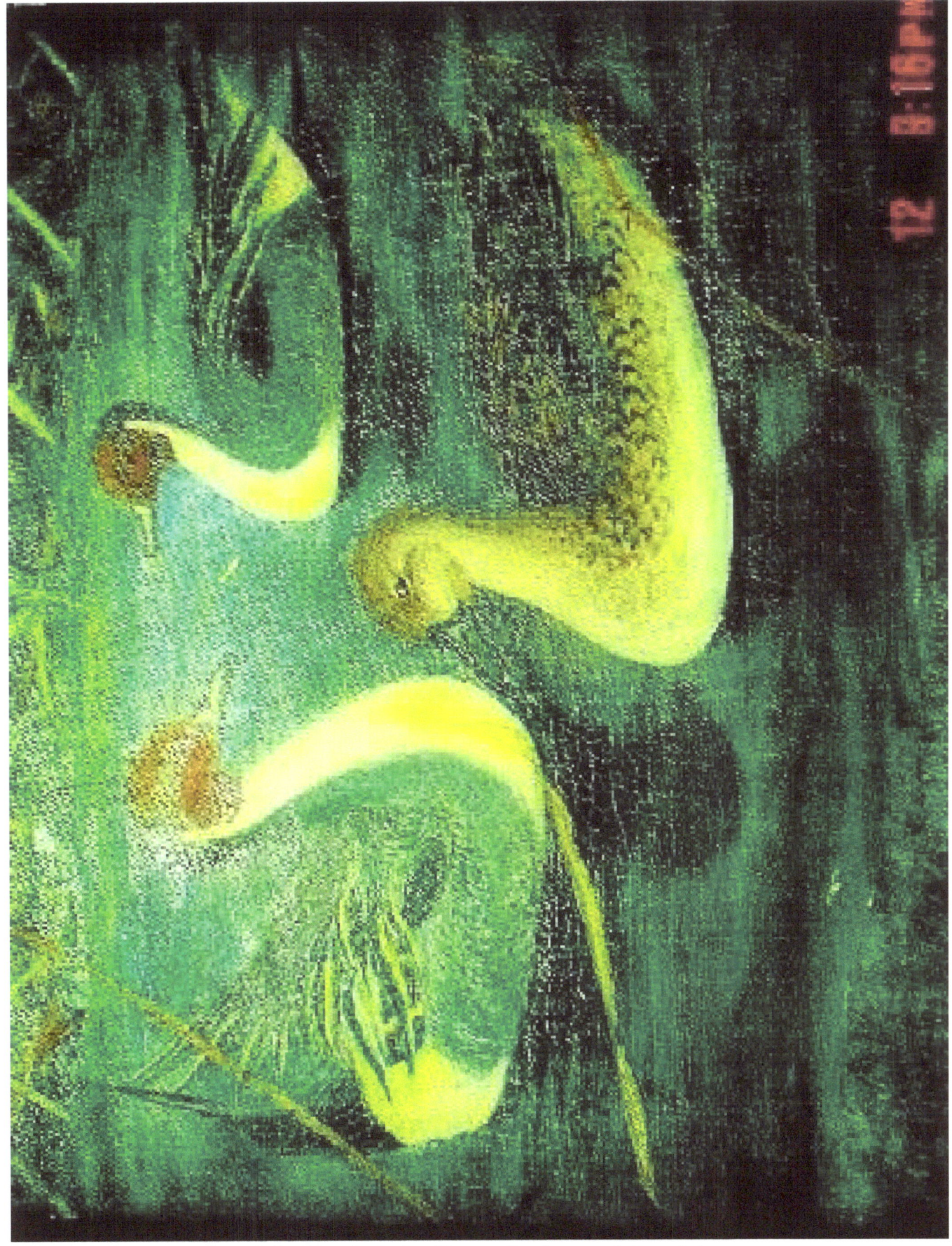

Itik (Ducks), by Pepe de Jesus (classic)

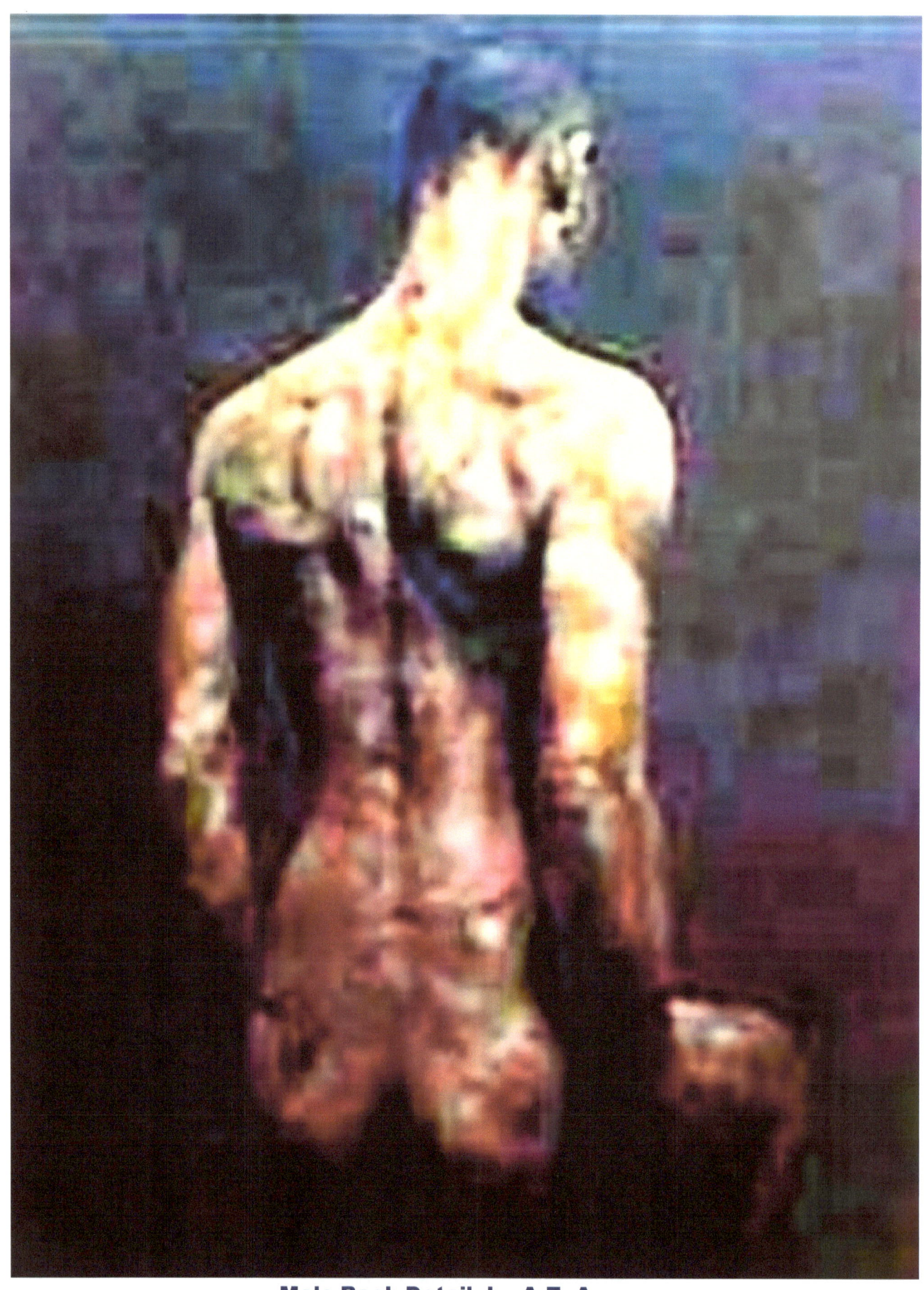

Male Back Detail, by A.Z. Anwar

www.ingramcontent.com/pod-product-compliance
Lightning Source LLC
Chambersburg PA
CBHW051108180526
45172CB00002B/824